IMAGES
of America

TROPICAL STORM AGNES
IN GREATER HARRISBURG

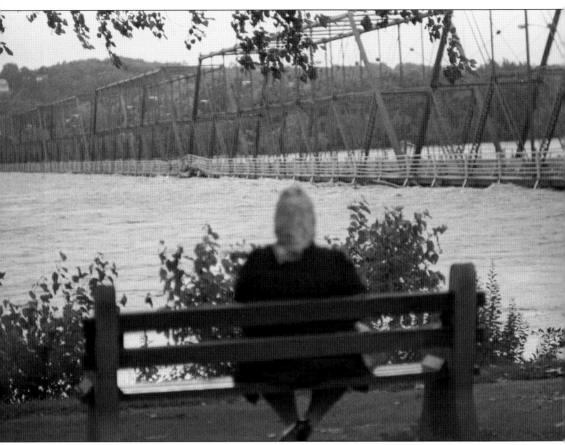

A solitary figure sits stoically in Riverfront Park contemplating the floodwaters of the Susquehanna River as they rise up to historic levels and meet the Walnut Street Bridge. (Courtesy of the Historical Society of Dauphin County.)

ON THE COVER: Bob and Nance Woodward struggle against the raging current of the Paxton Creek, which had left its banks and transformed South Tenth Street into a raging river. (Photograph by Thomas Leask of Allied Pix Services, Inc.; courtesy of the Historical Society of Dauphin County.)

IMAGES
of America

TROPICAL STORM AGNES
IN GREATER HARRISBURG

Erik V. Fasick

ARCADIA
PUBLISHING

Published by Arcadia Publishing
Charleston, South Carolina

Printed in the United States of America

Library of Congress Control Number: 2012945820

For all general information, please contact Arcadia Publishing:
Telephone 843-853-2070
Fax 843-853-0044
E-mail sales@arcadiapublishing.com
For customer service and orders:
Toll-Free 1-888-313-2665

Visit us on the Internet at www.arcadiapublishing.com

*To Danielle, Jack, and Julia, who have supported me
in my endeavors and humored me in my follies*

CONTENTS

ACKNOWLEDGMENTS

I owe many thanks to the numerous individuals who contributed to this work, but no one more than Jim Bradley and Pete Rekus, whose work and wisdom brought this particular segment of the past into perspective. It was their photographic work preserving the past that, along with the work of Thomas Leask, Norman Arnold, Ronald Coleman, Dennis Nye, Francis V. Smith, Randy C. Smith, Anthony Jones, Edward H. Beaver, and the reporters and staff of the *Patriot and Evening News*, made this volume possible.

I also owe much gratitude to the Historical Society of Dauphin County and its board of trustees and staff for the opportunity, environment, and resources to carry this project through from a mere suggestion to this finished product. All of the images contained herein are from the society's archives.

Much of this work would have been little more than bare photographs without the stories, reminiscences, knowledge, and input of Michelle Fox; Jay and Sandee Delozier; Tom Shue; Mary Ellen Kindness; Jim Kohler; Bob and Nance Woodward; Tony Spagnolo; Marie Iaria; Dave Houseal; Linn Lightner; Colleen and William Fisher; Linda Pugh-Funk and William E. Funk Jr.; Rebekah and William Deitz; Hicham, Melissa, and Zach Mouhssin; John Garver and the staff of the Tri-County Boat Club; Steve Fehr; Fred Lauster; Jerry Bell and Donna Heller Zinn of the Perry Historians; Donna Nissel and Douglas Johnston of Fairview Township; Evan Semoff; New Cumberland River Rescue; Scott Fair of the Goodwill Fire Company in West Fairview; Christine Anderson; Nelson Powden; Barbara Barksdale; Calobe Jackson; John Robinson; Jeb Stuart; Steve Bachmann; Ken Frew; Kathy McCorkle; Evelyn James; Kyle Weaver; Jesse Teitelbaum; Glen Dunbar; my editor, Abby Henry; and all those who offered advice and guidance along the way.

I am also greatly indebted to the works of Dan Cupper, Richard H. Steinmetz and Frederick A. Kramer, A. Keith Zorger and Frank E. Schubert, and John B. Yetter for their scholarship and research.

Thank you all.

INTRODUCTION

In 1794, George Washington stopped in Harrisburg en route to Carlisle and addressed his troops in Market Square. The stone slab on which he reportedly stood while giving the address was later inscribed, noting the occasion. This slab was later relocated to the Harris-Cameron Mansion on Front Street, near the Susquehanna River. A short distance from the slab and mansion, the Philadelphia & Reading Railroad Bridge spans the Susquehanna. Painted on one of the concrete support piers are a series of lines and numbers indicating the river stage. These markings are especially useful to the nearby residents of the riverfront neighborhood of Shipoke, who keep an eye cast towards the Susquehanna as it begins to rise. The uppermost of these lines is one that is situated above the 30 feet mark and does not have a number next to it, just "Agnes 1972." The "1972" is largely superfluous. "Agnes" alone would have sufficed to mark the occasion.

This painted message, along with the line on the river gauge on City Island, the plaque at the Sled Works in Duncannon, and the small plaque on the wall in Semoff's Barber Shop in New Cumberland, are small reminders of Agnes's brief but devastating visit to the Harrisburg area. But 40 years have passed, and those who witnessed Agnes firsthand are at least middle-aged. Many others have passed on. The question that begs to be asked is simply, can we afford to forget?

Prior to the arrival of Agnes in June 1972, an air of complacency seems to have settled over the region in regards to the danger of flooding. The last major flood was the flood of 1936, when the Susquehanna River crested at just over 29 feet in Harrisburg. Historian and journalist Paul Beers wrote, "The prediction that came out of 1936 was that it could happen only once every 200 years." And while measures were put into place following the 1936 flood to protect against future floods of that magnitude, what occurred 36 years later when Agnes arrived was not of the same magnitude.

On Monday, June 19, Agnes made landfall over the Florida Panhandle as a Category 1 hurricane, with sustained winds of 75 miles per hour. Over the next 48 hours, the storm continued overland, curling up the eastern seaboard and weakening to a tropical depression along its way. On June 21, Agnes reached the Virginia coast, where it was reinvigorated by another low-pressure system, intensifying Agnes to tropical storm status with sustained winds of 70 miles per hour. By June 22, Agnes again turned towards the East Coast, crossing overland near New York City and moving across northeast Pennsylvania as it headed north. On June 23, Agnes was absorbed into a low-pressure system and was no longer a threat.

However, over the course of June 21 and June 22, nearly 15 inches of rain had fallen in Harrisburg. The same was true to the north of the city along the main and western branches of the Susquehanna. All of this rain fell onto saturated ground that could not hold any more moisture, so the runoff was forced into the surrounding creeks and streams and ultimately back into the river, which headed south towards Harrisburg.

The first significant round of flooding in the city occurred on the morning of June 22 from Paxton Creek, which transformed into a raging torrent several city blocks wide. The amount

of water rushing down from Wildwood Park was so intense that one resident reported seeing a three-foot wall of water coming down Cameron Street at the intersection with Paxton Street. It was this floodwater that prompted the evacuation of neighborhoods and businesses all along the Cameron Street corridor and ultimately took the lives of two individuals.

As Paxton Creek was running amok in the city streets, the Susquehanna River was at 15 feet, still two feet below flood stage. But over the next 15 hours, it would rise, on average, nearly one foot per hour, reaching 28 feet by 3:00 a.m. on June 23. The river would eventually crest at 32.8 feet at noon on June 24.

Due to the varying heights of the riverbank, not all of the riverfront was flooded. At Division Street, the floodwaters reached back to the Polyclinic Hospital and covered the gardens surrounding Italian Lake. At Maclay Street, the Governor's Mansion let in five feet of water on the first floor. The executive residence had only been in use since 1969, when the previous governor's mansion, at Front and Barbara Streets, was deemed inadequate and ultimately torn down. Ironically, the place where the previous governor's residence once stood did not flood and remained dry.

Where the water did come up over the banks, there were additional problems beyond evacuating residents and water damage to personal property. Transportation and evacuation routes, for the public and for emergency personnel, were either limited or inaccessible. Public safety became a concern, with police forces spread thin throughout the widely flooded areas. The mayor's office instituted a citywide curfew, and the National Guard was called in to deter crime and limit accessibility to the evacuated areas. Evacuees, numbering in the thousands, were in need of shelter, food, and consolation. Dozens of public shelters and private homes were opened to take in these homeless individuals.

These problems were addressed on the fly, with strong leadership and great coordination between numerous agencies. Given the circumstances presented to those individuals and groups, they were largely successful in addressing the problems thrown at them. But there were also great losses caused by Agnes. More than 100 lives were lost, billions in dollars of damage to personal and public property took place, and whole neighborhoods were wiped off the map. There will not be another Agnes—the name was retired after the storm had left its mark—but there will be another storm like her. It is just a matter of time.

This work has been arranged to provide a tour of the region that is, for the most part, geographic in nature. Unfortunately, neither the resources nor the space was available to adequately document Agnes from a chronological perspective. The photographs presented here were taken exclusively from the archives of the Historical Society of Dauphin County, with the vast majority coming from the Allied Pix collection.

Allied Pix Services, Inc., provided photographic coverage for the *Patriot and Evening News* in Harrisburg from 1952 until 1994. Sadly, only a small fraction of their negatives from before Agnes survived, as the company's home office on North Cameron Street took on more than eight feet of water from the flood. The surviving photographic negatives were donated to the Historical Society of Dauphin County for educational and research purposes. The other contributions seen here were provided by both professional and amateur photographers. Randy Smith, a professional photographer who happened to be traveling through the area, was staying at the Nation Wide Inn when Agnes arrived. Edward H. Beaver and Anthony Jones were amateur photographers and residents of Harrisburg.

One

WEST SHORE
COMMUNITIES

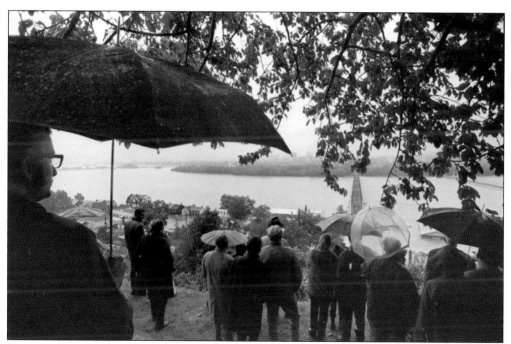

From the higher ground of Washington Heights in Lemoyne, onlookers gather to watch the Susquehanna River Valley transformed by Agnes's flooding rains. Directly below, the river's current was already flowing down the streets and into the homes and businesses in the borough of Wormleysburg. Across the river, to the north, a plume of smoke faintly rises from a row home fire on North Second Street.

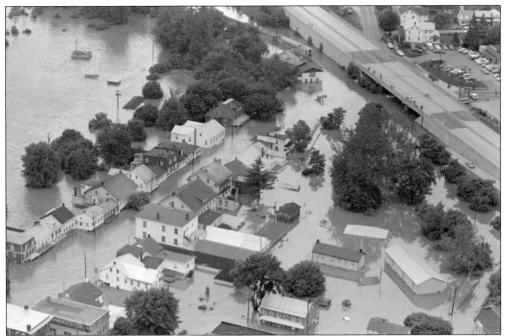

This aerial view of Duncannon was taken on June 24 as the floodwaters were cresting. Here, the Susquehanna River has extended into the borough, covering the first story of most of the buildings on South Market Street. The Little Juniata Creek, which in this view would normally run parallel with Routes 11 and 15, is no longer discernable. However, in the lower right corner, the lenticular trusses of the South High Street Bridge can be seen above the waterline.

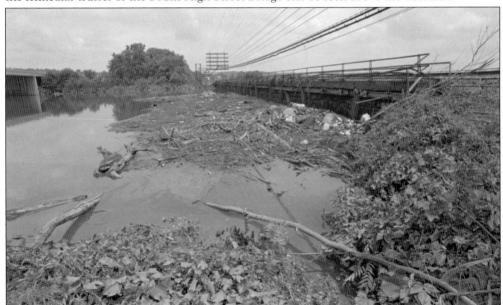

This photograph, taken on June 26, shows the glut of debris that collected against the Pennsylvania Railroad stone arch bridge over Sherman's Creek. Even two days after the floodwaters had crested, the height of the creek had still not dropped sufficiently for the debris to pass under the bridge and out into the Susquehanna.

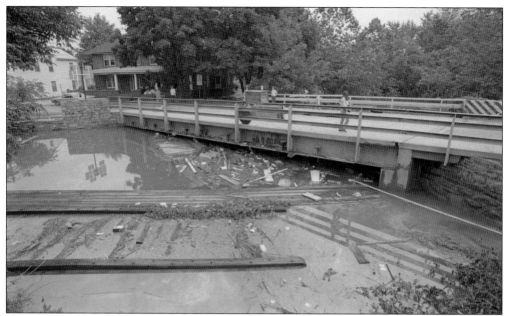

This view shows Little Juniata Creek and the bridge crossing over at Market Street towards the town square. The structure of wooden boards in the foreground running along the bank of the creek is more than likely a railroad siding that was utilized by the Pennsylvania Railroad or the Susquehanna River & Western rail line.

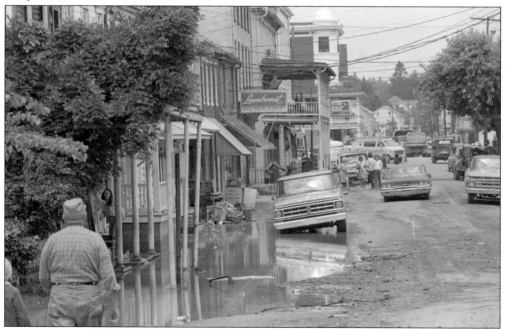

In the days after the floodwaters receded, Market Street in Duncannon was bustling with activity. However, the borough was not only threatened by the floodwaters, but also by what they brought with them. A 2,500-gallon tank of liquid nitrogen floated downstream towards the community from Mifflintown. Soon after returning to their homes after the flood danger passed, residents were forced to evacuate again because of the explosive threat from the nitrogen tank.

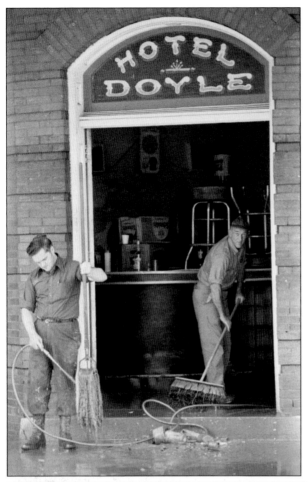

At the Hotel Doyle along Market Street in Duncannon, mud and debris are swept out of the barroom of the local landmark. The 1905 building is now a popular stop for hikers traveling along the Appalachian Trail. This building replaced the National Hotel, which Adolphus Busch bought into in 1897 as an outlet to dispense his Anheuser-Busch products.

Snow shovels like the ones below seem to have been the preferred cleanup method after the flood at The Pub, which is still located at the corner of Ann and Market Streets in Duncannon.

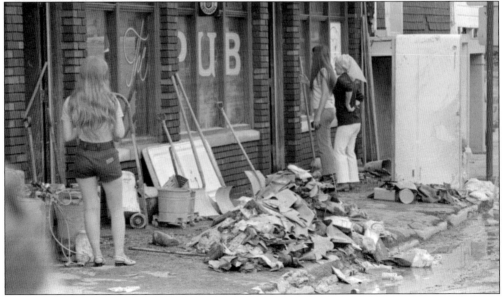

Along Maple Street in Duncannon, neighborhood children lend a hand in the cleanup process, pushing mud down towards Market Street. The building on the immediate right was the Duncannon Variety Store, at 15 North Market Street.

Below, headed down Market Street and out of town, truckloads of flood debris are hauled away as Duncannon tries to put Agnes in its rearview mirror.

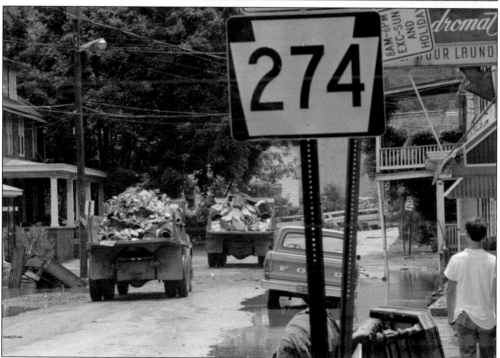

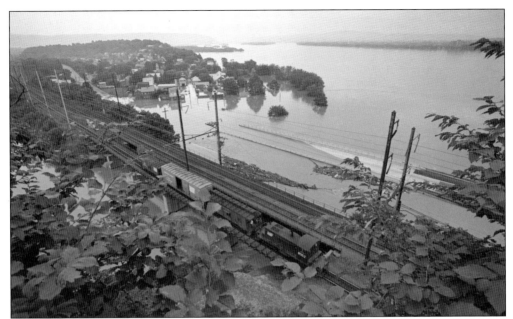

The village of West Fairview is nestled between the Susquehanna River to its east and the mouth of Conodoguinet Creek to the south. On June 24, when this photograph was taken, the Susquehanna had risen above 32 feet, flooding the lower end of West Fairview and backing into Conodoguinet Creek.

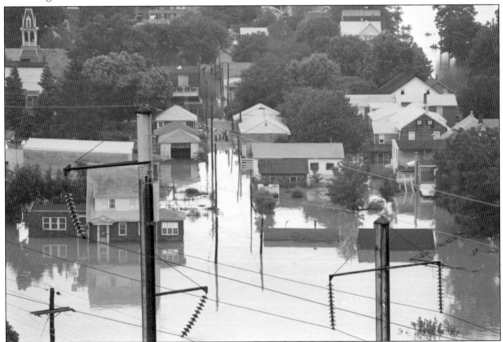

This closer view down into West Fairview reveals the varying elevations of the properties sharing the alley between Front and Second Streets. The floodwaters barely cover the doorsteps of the houses on the left, whereas to the right of the alleyway, just a few yards closer to the river, only the rooftops of the buildings in the foreground are still visible.

14

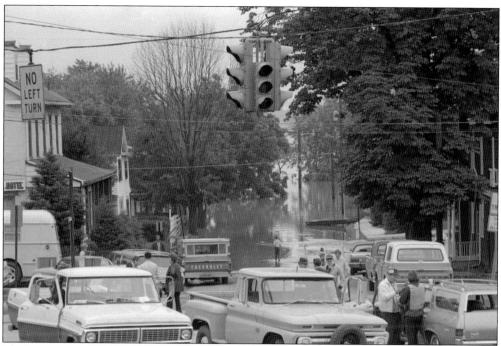

The intersection of Market Street and State Route 11/15 in West Fairview is transformed into a parking lot and public meeting place as vehicles and residents seek higher ground above the floodwaters.

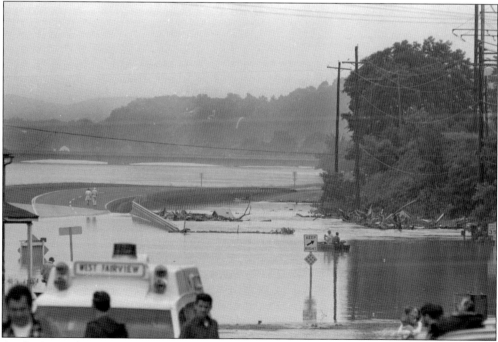

As the Susquehanna River backed into Conodoguinet Creek, water covered a critical portion of Route 11/15, which served as the only direct route into Wormleysburg and other points south. This posed a problem for emergency responders attempting to transport patients to Holy Spirit Hospital. With the river route cut off, an alternative route on higher ground was needed.

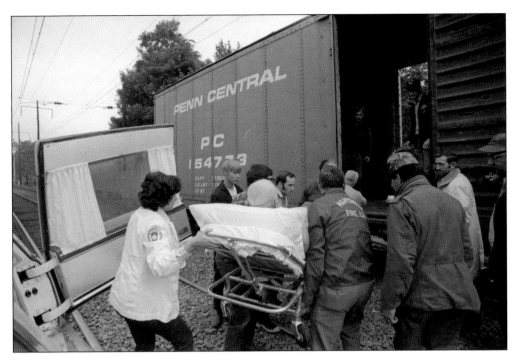

The transportation solution came in the form of a short train ride. Patients were brought by ambulance to the rail crossing above Market Street in West Fairview and placed in a boxcar. From there, the train traveled less than one mile south to the rail crossing at Poplar Church Road in Wormleysburg (below). The run was given the unofficial name "Penn Central Shuttle Service" after the Penn Central Railroad, which owned and operated the rail line.

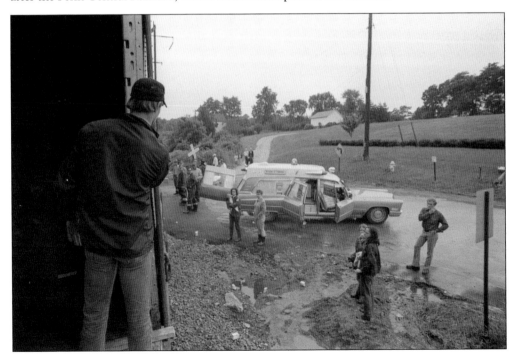

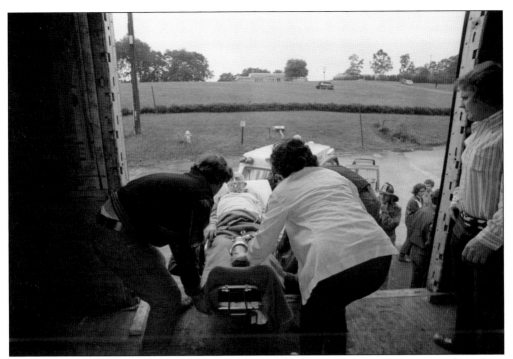

While transporting patients in an open boxcar was not the smoothest way to move them from one point to another, the alternative would have been trying to navigate around the flooded Conodoguinet Creek, which twists and turns its way down to the Susquehanna River.

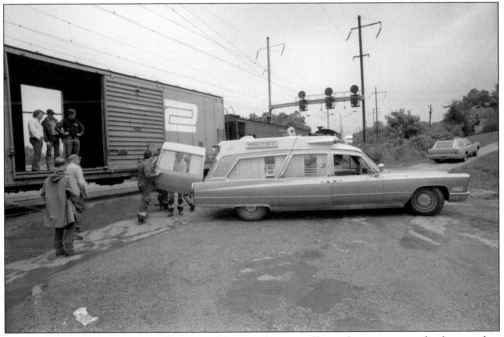

The shuttle service was a success because of the coordinating efforts of emergency medical responders from several different municipalities. The situation required a full complement of volunteers on both ends of the line, each with limited means of communication at their disposal.

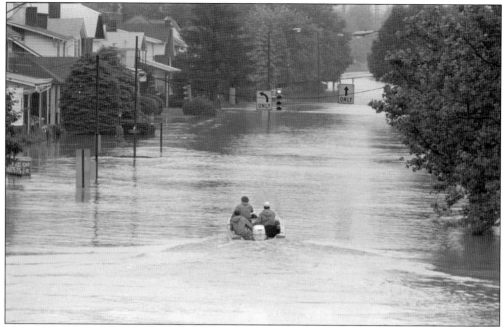

The traffic along Front Street is light as a boat approaches the signal at Stella Street in Wormleysburg. This photograph was taken on June 23, when the stage of the Susquehanna River was over 30 feet and still climbing towards its eventual crest.

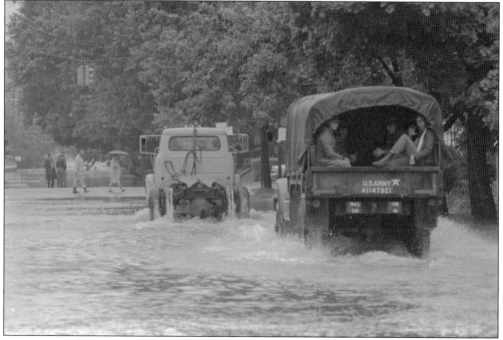

A US Army transport truck carrying members of the Pennsylvania National Guard plows through the accumulating floodwaters along North Second Street in Wormleysburg. Sightseers take advantage of the slightly raised elevation of Walnut Street for a closer look at the flooded riverfront.

Emergency vehicles block the intersection of Walnut and Front Streets in Wormleysburg as the wide expanse of the Susquehanna River inches its way up into the borough.

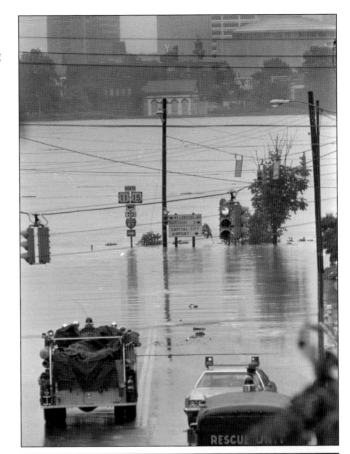

With a little push, the boat below is launched out onto Ferry Street in Wormleysburg, where the water was still only a few inches deep on June 23. Within 24 hours, the river rose an additional two feet, and little pushes were no longer needed.

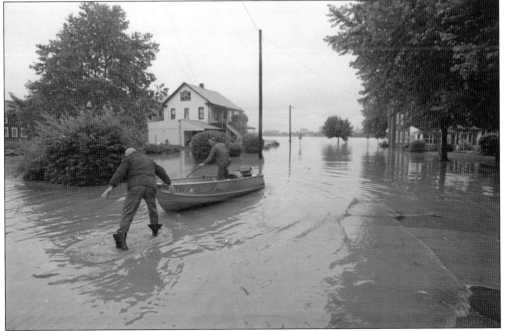

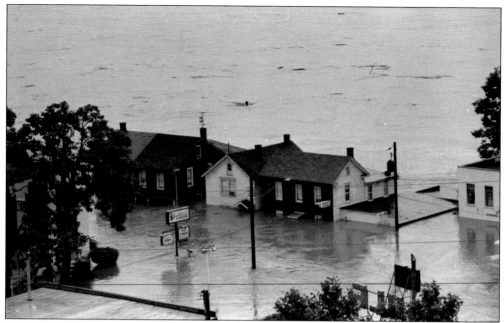

This view looks down on to Front Street in Wormleysburg, where the Susquehanna River has nearly reached the second floor of the frame buildings along the riverfront. Surprisingly enough, these buildings survived Agnes's onslaught and even remained standing after Hurricane Eloise arrived in September 1975.

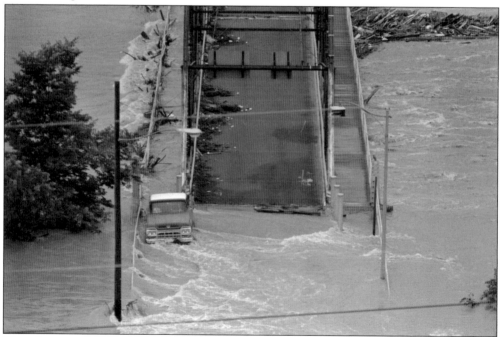

This photograph of the western approach of the Walnut Street Bridge was taken on June 24 as the river was cresting and shows that, although the bridge was beaten severely by objects drifting downstream, the deck of the bridge remained relatively dry. The owner of this abandoned pickup truck was not so fortunate.

The wide expanse of the Susquehanna River extends to cover nearly everything at the west end of the Market Street Bridge. This photograph was taken on June 23 while the river was still rising. By the following day, the roadway on the entire west side of the Market Street Bridge was under water.

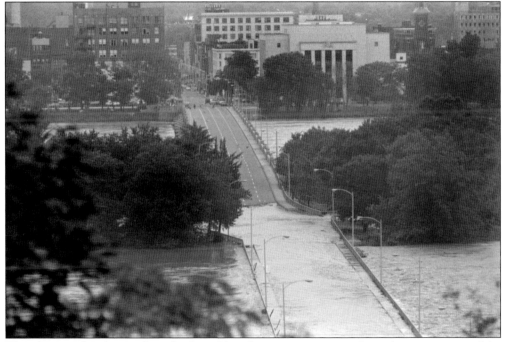

This photograph, taken on Saturday, June 24, as the river was cresting, shows the western span of the Market Street Bridge as it approaches City Island. The floodwaters flowed across the bridge's deck, but the railings remained above the waterline. However, on the eastern span of the bridge, the floodwaters never reached the roadway because of its arched shape and the height of the riverbank.

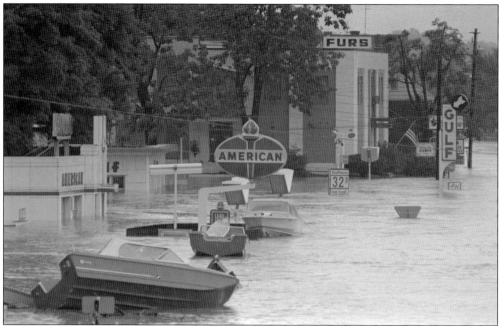

Various boats drift and collect in the lower end of the bottleneck in Wormleysburg. The American and Gulf gas stations were located in the area, which is now used for parking lots for restaurants along the riverfront. Charles' Furrier is situated on a small rise of land and appears to have stayed above the waterline.

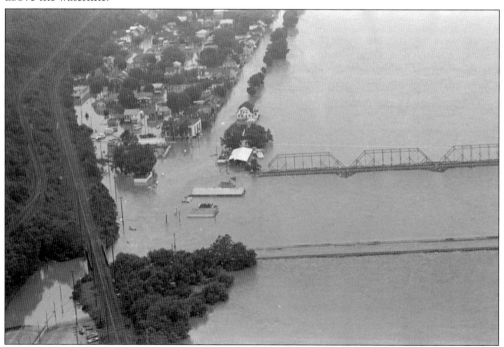

This aerial view of the bottleneck and Wormleysburg was taken on Saturday, June 24, as the Susquehanna River was cresting at over 32 feet. At this height, the river flooded the entire riverfront portion of the borough, contained only by the railroad embankment.

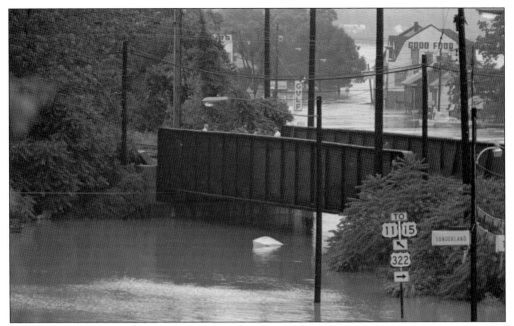

The clearance under the railroad bridge at the bottleneck is currently marked at 14 feet, two inches. From this photograph looking upriver into Wormleysburg, the floodwater from the Susquehanna has risen to a level of about 10 feet. In the distance is the Beach Front Hotel Restaurant, with the words "Good Food" written on the gable end of the building. After the flood, the restaurant was ultimately replaced by another restaurant called The River Boat.

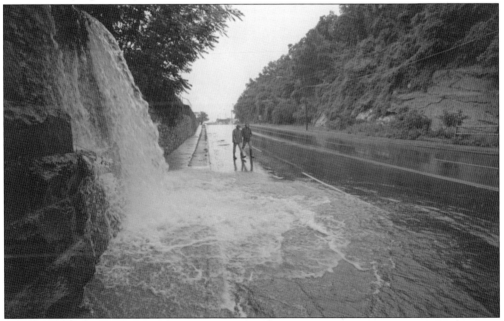

Like a small waterfall, groundwater spills over from the train yard above onto Market Street, just above the bottleneck in Lemoyne. Like many other West Shore communities, Lemoyne experienced only minor problems, mainly flooded basements and backed-up sewer lines, due to the large amount of runoff from the rainfall.

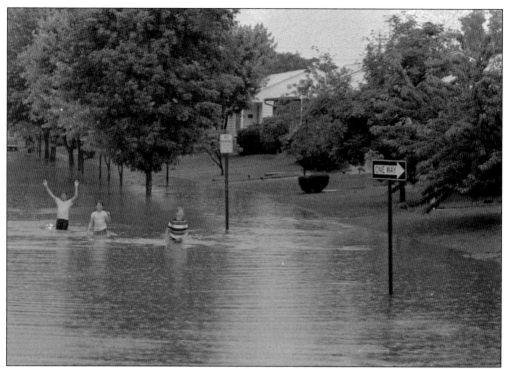

This low point on Kingsley Drive, directly behind the Cedar Cliff Mall in Lower Allen Township, is transformed by the heavy rains on June 21 into a pond for the local neighborhood kids.

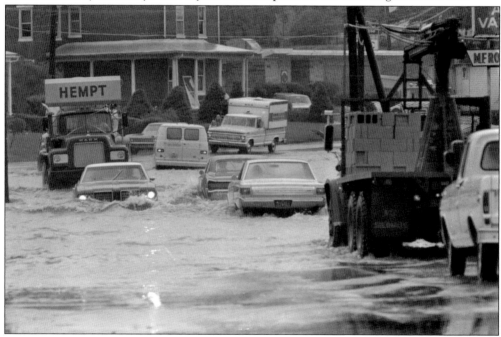

Cars and trucks slog through the flooded intersection of Spera Drive and Old Gettysburg Road in Lower Allen Township. The flooding is the result of runoff from the heavy rains and nearby Cedar Run.

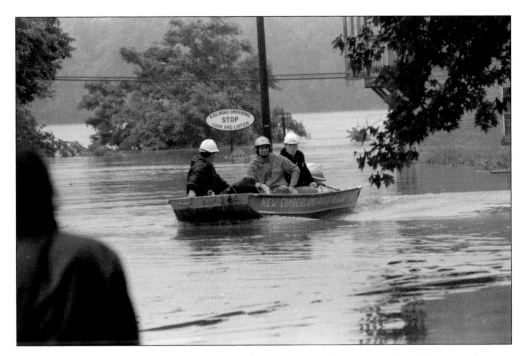

In the photograph above, a New Cumberland River Rescue boat piloted by a New Cumberland borough police officer patrols along Fifth Street, just above Water Street. As a result of the Agnes flood, New Cumberland River Rescue lost all but one of its boats. Below, along Market Street, just above Pete's Café, the same New Cumberland River Rescue crew inspects homes for signs of residents who may have been stranded by the floodwaters.

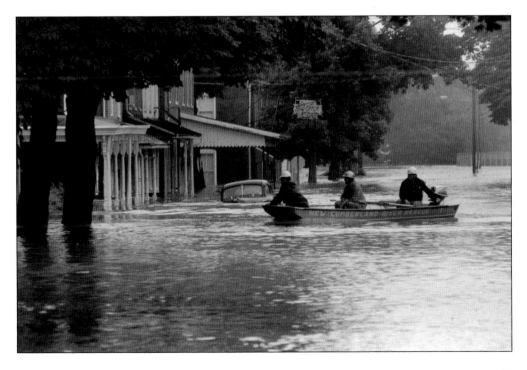

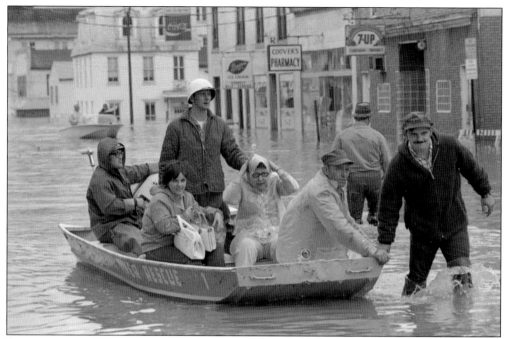

On June 23, just below the intersection of Third and Bridge Streets, a New Cumberland River Rescue boat filled with evacuees is pulled through the knee-deep floodwaters. At Semoff's Barber Shop on the corner of Third and Market Streets, a small plaque was placed on the wall at the height of the high-water mark, which reached nearly five feet above street level.

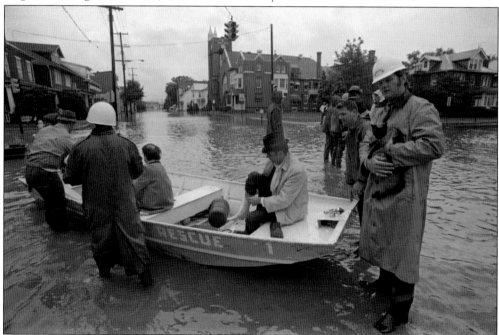

While the depth of the water was only a few inches deep at the intersection of Third and Bridge Streets in New Cumberland, just a few blocks away at the iron bridge, Yellow Breeches Creek had risen 10 feet above its banks when the rising Susquehanna River backed into the creek.

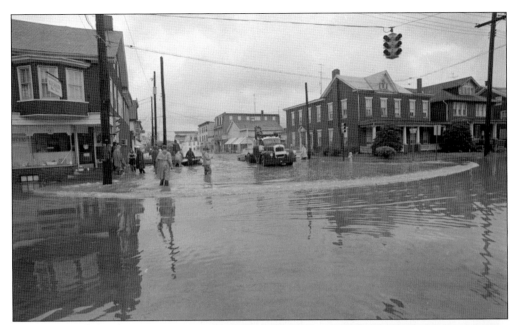

Above, a small floodwater tidal wave caused by a tow truck pulling cars out of the deepening floodwaters spreads out across the intersection of Third and Bridge Streets.

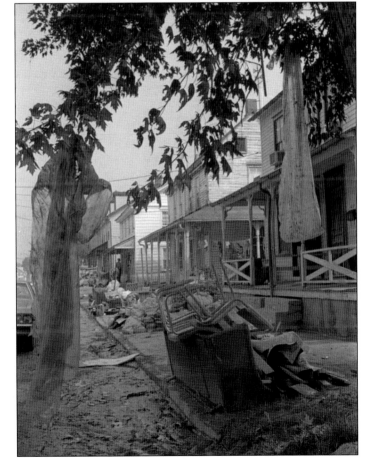

Along the 100 block of Market Street in New Cumberland, the curbside is lined with furniture and family possessions damaged from the floodwaters from Yellow Breeches Creek and the Susquehanna River. The water here reached a depth of more than six feet.

27

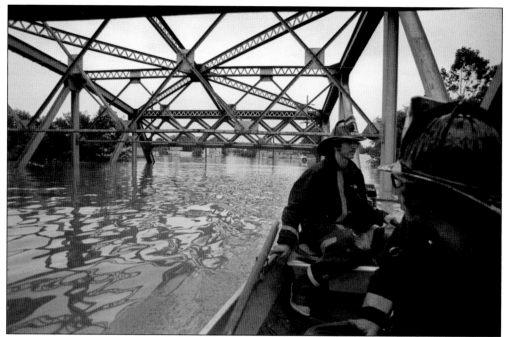

A boat manned by volunteer firefighters from Fairview Township navigates across the iron bridge on Bridge Street on June 24. Allied Pix photographer Jim Bradley commented that the water level was so high that one could reach up and touch the girders of the bridge.

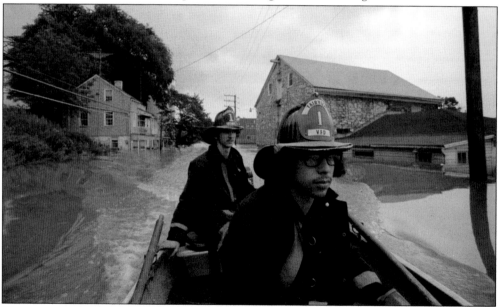

These two firefighters patrolling the streets-turned-waterways are Jim Kohler (foreground) and Dave Dominoski (background). Reflecting back after 40 years, Kohler recalled the long hours spent looking for individuals who may have been trapped in their homes or businesses. They are seen here traveling down Meadowbrook Road. In the background, to the right, is the Old Ross gristmill, which was built in 1814 by Jacob Haldeman. At the time of the flood, it was owned by the Riverton Water Company.

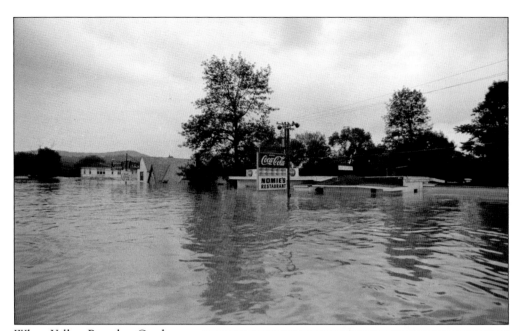

When Yellow Breeches Creek backed up due to the rising waters of the Susquehanna River, the businesses and mobile homes located along Old York Road were surrounded by up to 10 feet of water. Above, near Lewisberry Road (Route 114), the floodwaters nearly cover the entire first floor of Nomie's Restaurant and Pierre's Restaurant (in the left background).

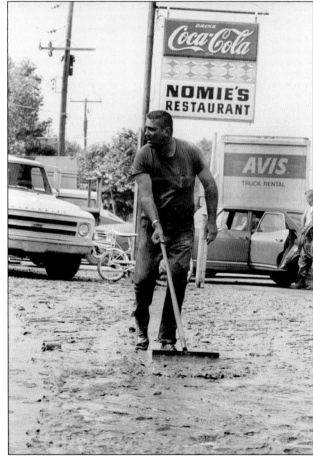

Two days later, the water that nearly covered Nomie's Restaurant was gone, having receded back into Yellow Breeches Creek and carried out into the Susquehanna. Left behind was a layer of mud and debris that took on the quality of cement if it was not removed before it hardened.

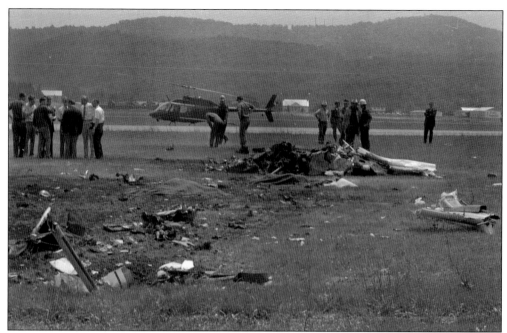

At approximately 2:00 p.m. on June 26, a helicopter carrying Sid Brenner and Lou Clark of WCAU-TV in Philadelphia and Del Vaughn of CBS in New York approached the Capital City Airport in Fairview Township. The men had been covering the flood for their respective news outlets. Brenner had previously worked for WHP in Harrisburg in the 1960s. As the helicopter approached the airport, the reports are somewhat conflicting about what exactly happened as they prepared to land, but it seems that the main rotor flew off the aircraft, causing the helicopter to become inverted. Whether the helicopter exploded in midair or when it hit the ground is unknown, but the end result was the same. The three newsmen and the pilot were instantly killed.

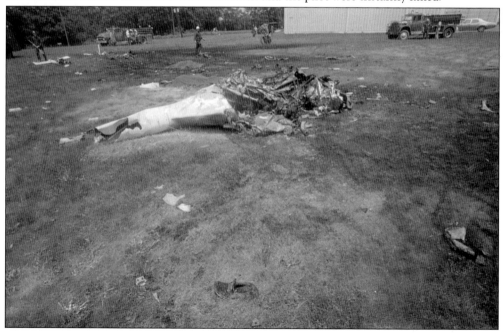

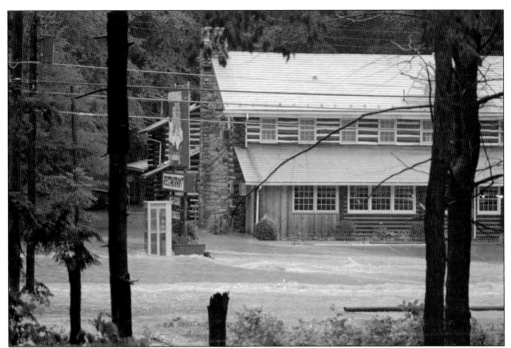

The heavy rains on June 21 and June 22 caused Mountain Creek to climb out of the banks along South Baltimore Avenue in Mount Holly Springs and into the parking lot of the Deer Lodge Restaurant.

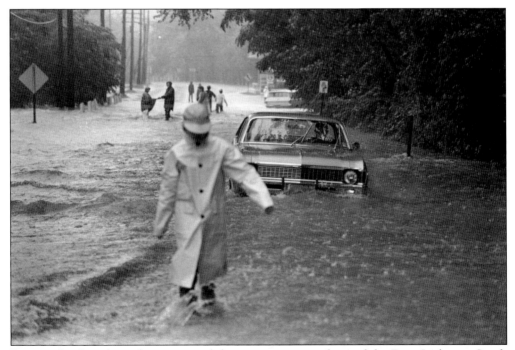

Despite the drenching downpour and deepening water in front of the Deer Lodge on South Baltimore Street, children and cars plod along as the weather conditions worsen.

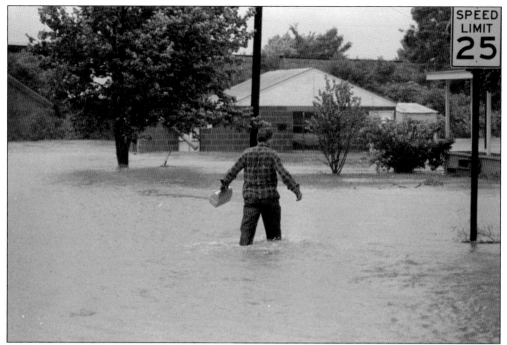

These two views, both taken on June 22, show Mountain Creek flowing down Mill Street in Mount Holly Springs. The above photograph shows a gentleman on his way home from work with his lunch pail turning to walk up Peach Street against the deepening current. Looking back up Mill Street, the photograph below shows a home at the corner of Mill and East Streets. Here, the swollen creek races across the relatively flat terrain, flooding the treatment plant, baseball field, and the small neighborhood of homes.

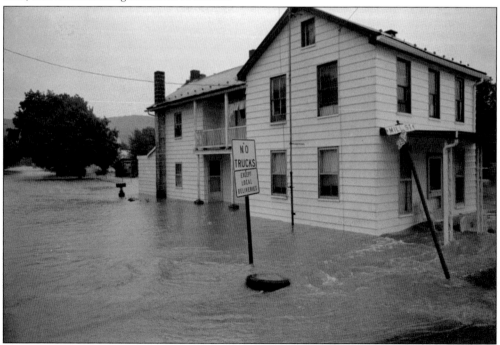

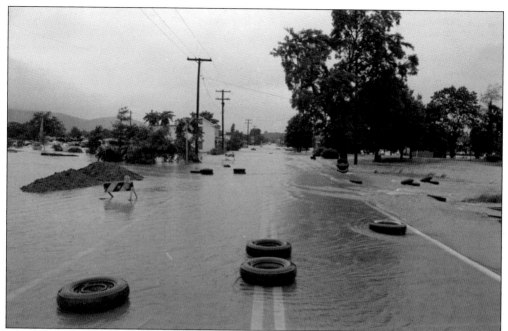

Floodwaters from Mountain Creek flowed with enough force to float old tires from a nearby junkyard and scatter them across Mill Street in Mount Holly Springs.

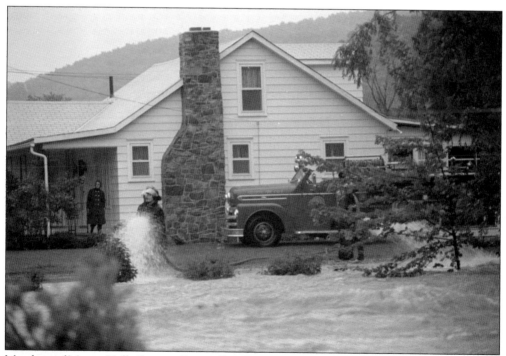

Members of Mount Holly Springs Citizen Fire Company No. 1 pump out the basement of a home on East Pine Street. Mountain Creek, which runs alongside the home, has swelled out of its banks and rages past in the foreground.

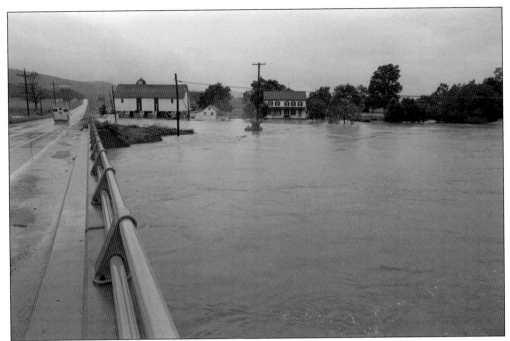

After two days of heavy rain, the banks that usually hold Yellow Breeches Creek near South Middleton Municipal Park are no longer perceptible as it sprawls out across Hinkel Lane and up to a farmhouse along Park Drive. The bank barn, seen here next to the road, is no longer located at this site.

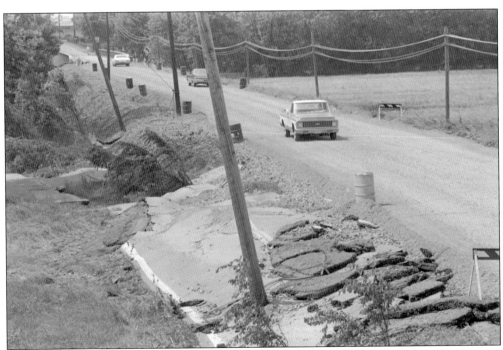

Just days earlier, Yellow Breeches Creek had leapt out from beneath the bridge in the distance and swept across this farmer's field to push the blacktop cleanly off the Holly Pike.

Two
EAST SHORE
COMMUNITIES

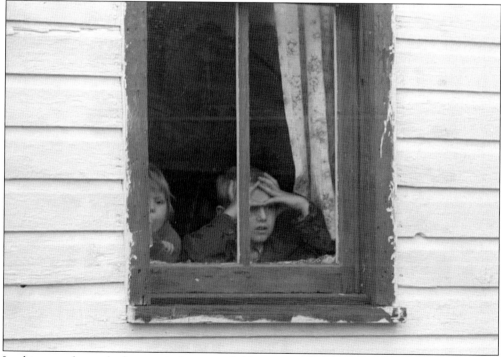

Looking out from a bedroom window, two children try to make sense of the scene outside their Middletown home, where floodwaters from Swatara Creek and the Susquehanna River have transformed their familiar neighborhood into a strange and alien world.

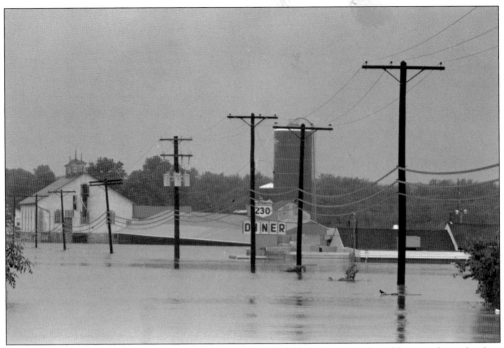

Along the East Harrisburg Pike, Stefanie's Route 230 Diner is inundated by nearly eight feet of water from nearby Swatara Creek, which lies behind the bank barn and farmhouse in the background.

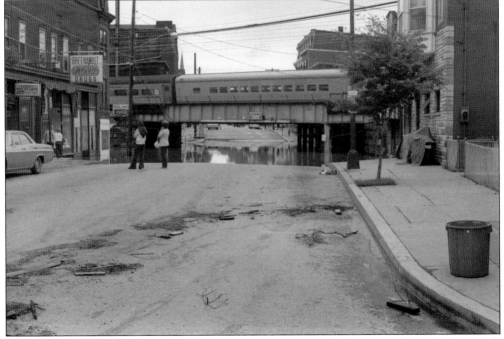

This view shows the flooded subway on South Union Street in Middletown. In the background, behind the railroad tracks to the left, is the Wincroft Stove Works. Sitting on the tracks in the middle of the railroad bridge is the Prairie Sunset, a Budd passenger car.

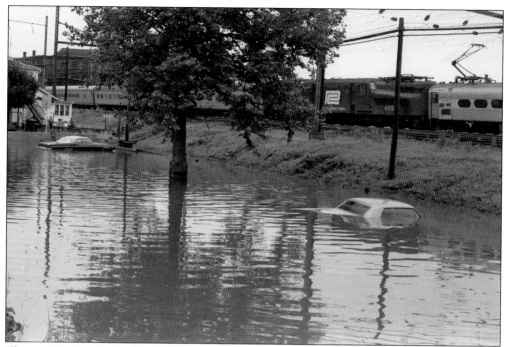

This parking lot, behind the Blue Room Bar & Grille, floods under several feet of water from nearby Swatara Creek. The stranded Penn Central GG-1 electric locomotive No. 4893 sits on the tracks above.

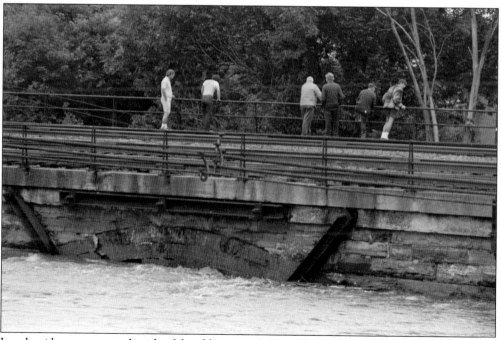

Local residents peer over the side of the old stone arch Pennsylvania Railroad Bridge to catch a closer glimpse of Swatara Creek, which has risen up to nearly cover the top of the bridge's arches.

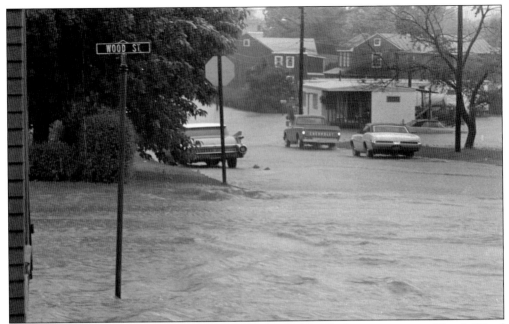

Above, runoff from the heavy rainfall flows like a creek through the intersection of South Wood and State Streets down to Swar Avenue. There it collects and deepens near a trailer home. This runoff eventually mingled with the floodwaters from Swatara Creek, which is only a few blocks to the west. The photograph below was taken from the same intersection after the rains had ended. The water at the stop sign has only risen to the knee of the gentleman standing near it. However, at Swar Avenue below, only the roof of a trailer home remains above water. The rapid rise in the floodwaters prompted a house-by-house search for anyone who may have been unable to evacuate the area.

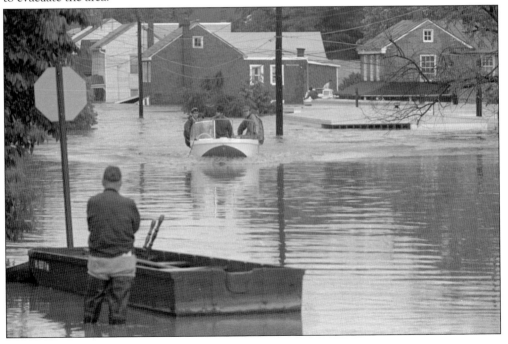

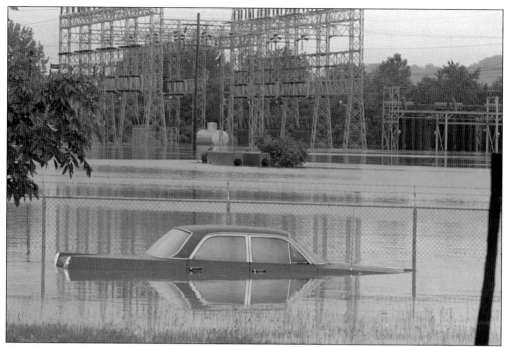

An abandoned automobile lies half-submerged beneath floodwaters outside of the power plant on Fisher Avenue in Middletown Borough.

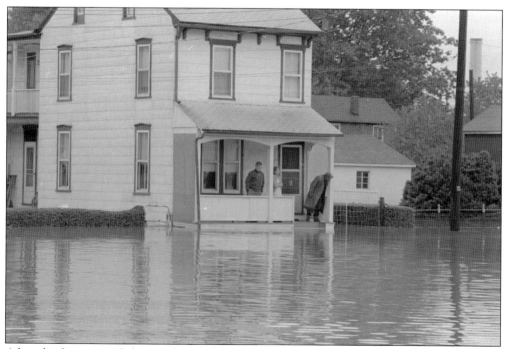

After checking in with his neighbors, this man peers off the front porch of their home at 116 Market Street in Middletown, waiting for a boat to come pick him up.

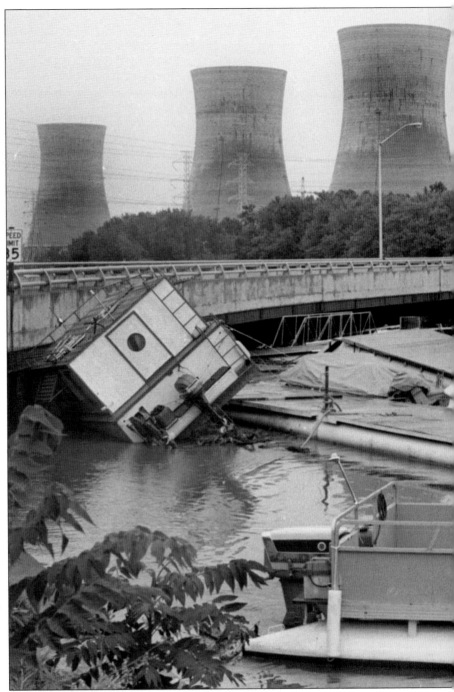

This image brings together the two most significant events that occurred in south central Pennsylvania in the last 150 years, the Agnes flood and the nuclear accident at the Three Mile Island power plant. When this photograph was taken in June 1972, the power plant was still under construction. Reactor No. 1 would not become operational until April 1974, and the infamous Reactor No. 2 would not come online until 1978. While the island did flood from the southern end, the northern end was fortified to withstand floodwaters from the Susquehanna

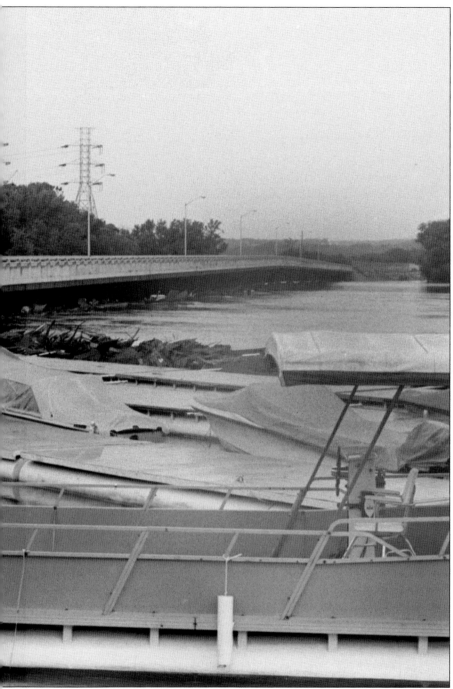

reaching a depth of 40 feet. Fortunately, the floodwaters at the island did not rise above 32 feet. This photograph also shows several types of watercraft and the floating docks they are still tied fast to lodged against the north bridge access to Three Mile Island. It is quite possible that the watercraft and docks floated the short distance downstream from the Tri-County Boat Club, which was flooded out by Agnes.

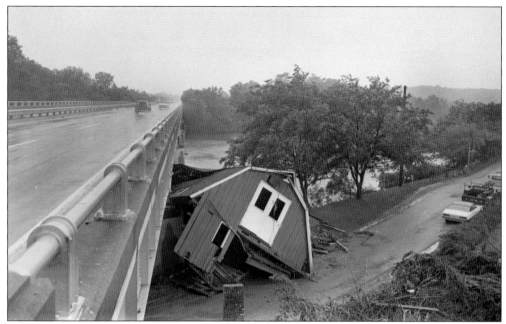

A large storage shed, too large to pass under the Turnpike Bridge, became wedged and ultimately crushed by the force of floodwaters pushing it against a bridge pylon. The shed did not travel far, only about 100 yards, after being picked up and carried from the property at the intersection of Swatara Creek and Newberry Roads.

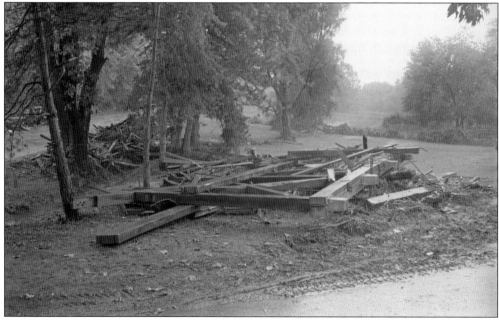

Swatara Creek is seen here in the days after the floodwaters had receded. The bridge trusses in the foreground are presumably from the Clifton Covered Bridge, which was destroyed during the flood. A close look shows that someone has propped up the truss with a jack. The bridge had crossed over the creek at Fulling Mill Road and Schoolhouse Lane, where a stone support pylon still stands.

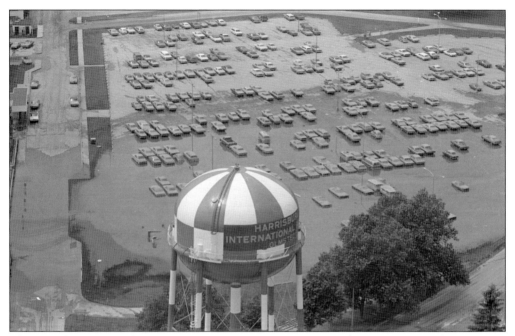

This aerial view was taken from above the water tower at Harrisburg International Airport on a sunny day following the flooding. Its parking lot is still partially covered with water and filled with scores of muddy vehicles.

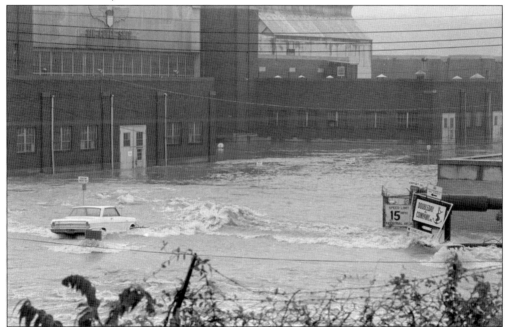

Floodwaters rush down Airport Drive at Harrisburg International Airport towards the warehouses used by the Doubleday & Company publishing firm and various state agencies. One casualty of the flood was a $3-million computer that was leased by the Commonwealth of Pennsylvania for payroll processing. A replacement computer was obtained at a fraction of the cost, but it required eight trucks to ship it to the location.

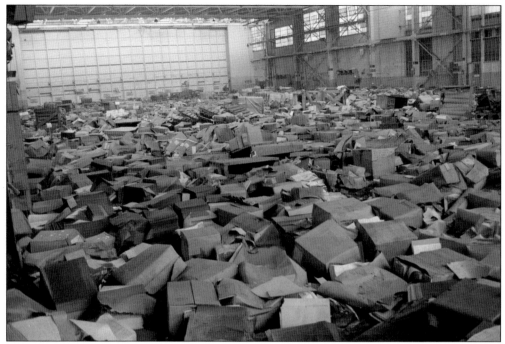

Thousands of boxes containing printed materials owned by the Commonwealth of Pennsylvania and its state agencies are strewn across a large hangar serving as a storage warehouse.

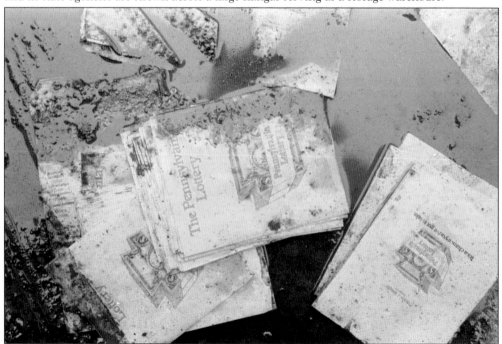

Pennsylvania Lottery promotional materials lay scattered in the mud. Formed in August 1971, less than one year prior to Agnes's arrival, the Pennsylvania Lottery housed its printed materials in a 10,000-square-foot warehouse at Harrisburg International Airport. The entire reserve of 45 million lottery tickets was lost when nearly 10 feet of water inundated the storage facility.

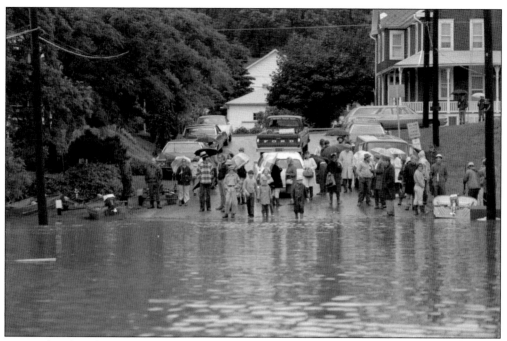

A crowd gathers by the water's edge on Ann Street in Highspire, just above the Little League baseball fields at Reservoir Park. At the time of the flood, Highspire mayor Earl Hoffman estimated that 75 percent of the borough was under water.

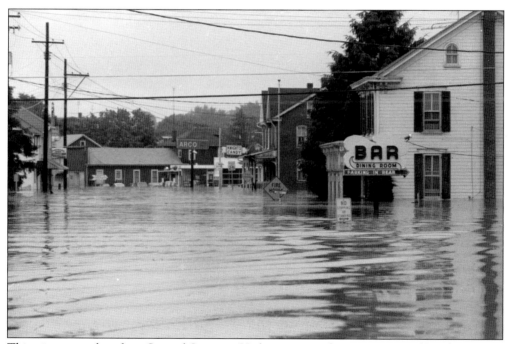

This view was taken from Second Street in Highspire, near the intersection of Lumber Street. The sign indicating the entrance to the firehouse parking lot is just above the waterline on the right.

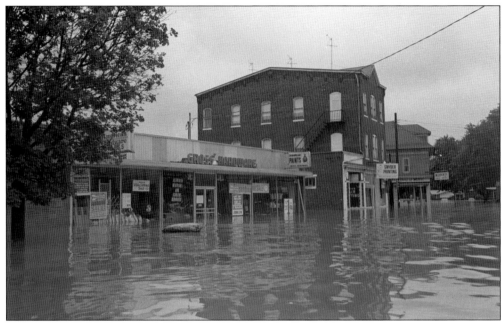

Farther up Second Street in Highspire, near Commerce Street, businesses seem to have been abandoned without any warning. Gross' Hardware is advertising its "Sunbound Sale" ending on June 24, and the storefront window display is stocked with bags of turf builder and lawn care supplies. Klock's House of Music was also hastily closed up, with an electric guitar still on display in its front window.

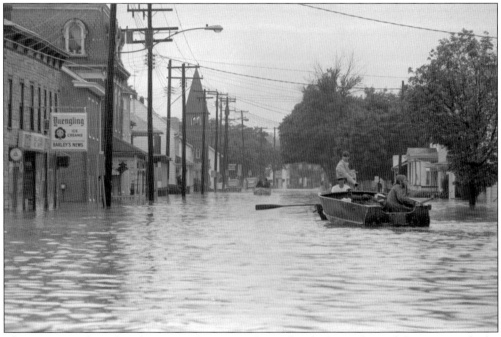

This view was also taken from near Commerce Street but looks up Second Street towards the Highspire First Church of God on the left. Several boaters were drawn out after the storm to take in the sights.

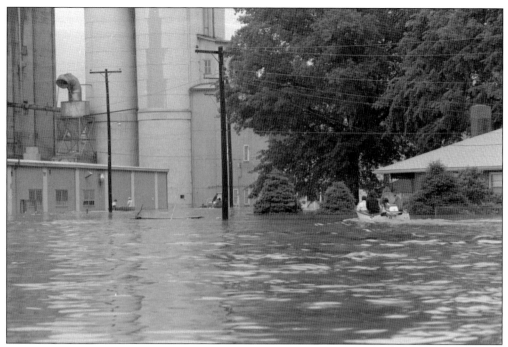

Boats converge near the local landmark of the Highspire Flour Mills, where Race Street and Lusk Avenue meet. During the Agnes flood, the mill was used for the production of Wheatena Toasted Wheat Cereal, which had been produced there since October 1967.

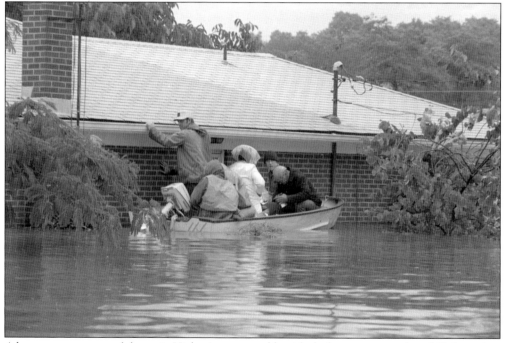

A boat stops near a ranch home in Highspire, presumably with the homeowners onboard. Perhaps they were coming back in hopes of salvaging some personal items before it was too late. Judging by the body language of the gentleman with his head down, the situation was worse than they expected.

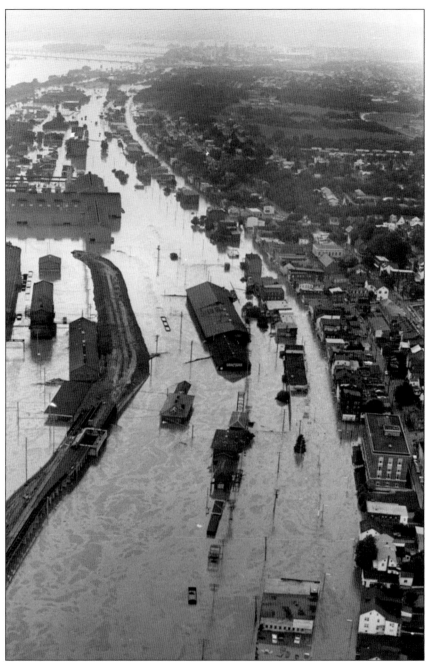

The borough of Steelton is seen here from the air on June 24, when the Susquehanna River was at its crest of 32 feet. The floodwaters reached inward to Front Street but were unable to ascend the grade to reach Second Street. However, the worst of the flooding was seen in the West End, which was closest to the river. The steel mill sustained the largest amount of damage and took the longest time to return to full capacity, keeping the mill workers out of work and without a paycheck. However, the greatest pain inflicted on the borough was felt by the residents of the West End. Damaged by Agnes, the neighborhood was taken from the residents and ultimately destroyed through a federal government renewal act.

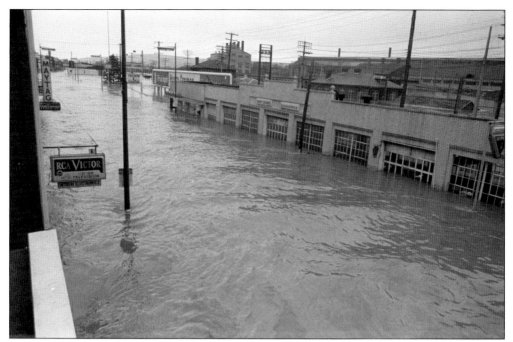

Floodwaters flow slowly past the service bays and showroom of the Harry Cramer Oldsmobile and Triumph dealership, which was located at 154 South Front Street in Steelton at the time. The Swatara Street entrance to the steel mill is just beyond the dealership.

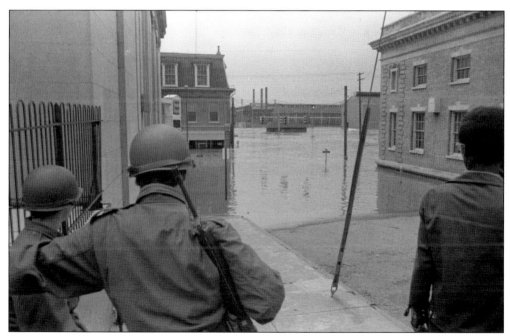

Two National Guardsmen, one with a rifle slung over his shoulder, stand watch over the Steelton National Bank and a branch of Dauphin Deposit Bank from the vantage point of Locust Street and River Alley.

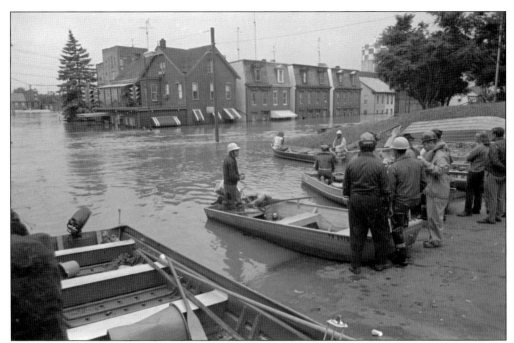

The base of Conestoga Street is transformed into a boat launch for emergency responders, including Harrisburg River Rescue, patrolling for individuals who may have been stranded in the flooded homes along Front Street or down in the West End.

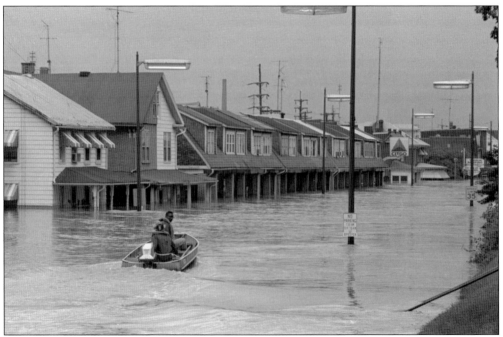

A boat carrying emergency personnel leaves the launch area at Conestoga Street and travels north on Front Street in Steelton. The floodwaters here are deep enough to cover the front porches of the homes along "Million Dollar Row."

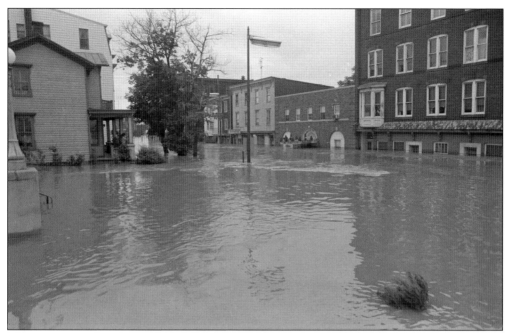

This view was taken from Angle Avenue and looks out across the front of the submerged plaza of the Steelton Borough Municipal Building. Nearby homeowners watch from their front porch as the water rises all around them.

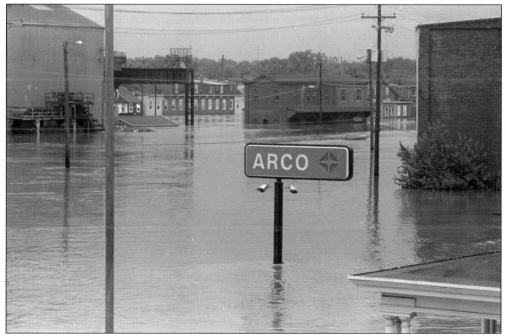

In the distance, directly above the Arco sign, is the Penn Central Railroad (formerly the Pennsylvania Railroad) Company Freight Station, located at 5 Trewick Street.

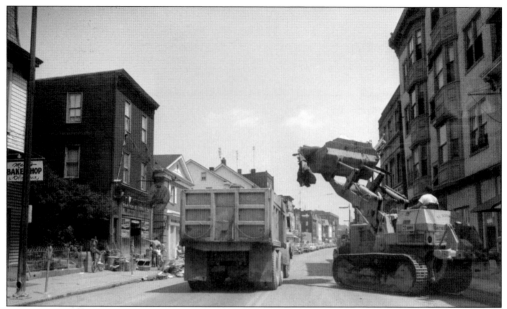

Outside of Wilt's Apartments and Lydia's Half Way House Hotel and Tavern on South Front Street in Steelton, heavy equipment is brought in to handle the cleanup operation. Across the street is the Barry Boys auto accessories and sporting goods store. None of the buildings seen in this view along South Front Street, between Cranberry Alley and Walnut Street, are still standing.

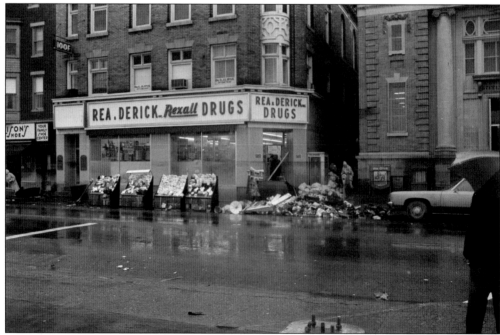

Along North Front Street in Steelton, Rea & Derick Drugs has begun the cleanup process after more than six feet of water filled their store. The damaged contents of the store, including the greeting card displays, are deposited out along the curb for pickup. Here, the black high-water mark can be seen across the storefront and on the telephone booth to the right of the building.

A crowd gathers at the water's edge on Conestoga Street just above North Front Street in Steelton to watch the floodwaters rise in the West End neighborhood. Prior to Agnes's arrival, the homes and businesses in the West End withstood more than a dozen floods, most notably the floods of 1889 and 1936. But sadly, the West End could not weather this storm and was slowly razed through demolition and fire in the years to follow.

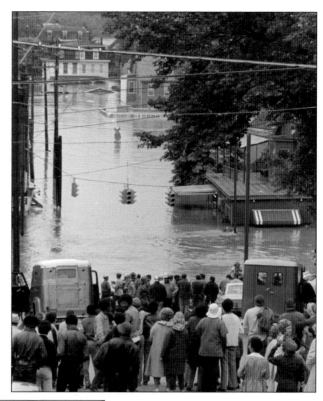

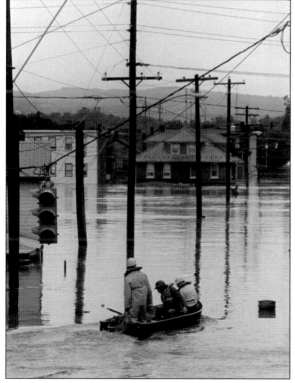

An emergency responder navigates a boat down Conestoga Street into the West End, using telephone poles as guides to stay on course, with debris and signposts just beneath the water's surface. Farther down in the West End, the river has risen up to the second stories of homes.

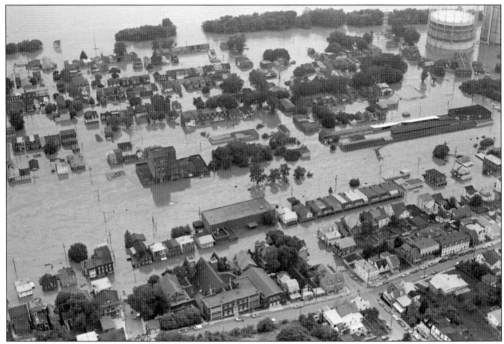

This aerial view, showing a portion of the West End, was taken on June 24 as the Susquehanna River was cresting at over 32 feet.

Looking down Trewick Street into the West End neighborhood, Dimich's Café is on the right at 202 Frederick Street. The high-water line can be seen on the side of the café at an estimated height of between eight and 10 feet. The rail mill is on the left.

Heavy equipment is brought in to clear away the flood-damaged items and debris that have been piled up near the intersection of Conestoga and Main Streets in the West End. The West End neighborhood was largely made up of mill employees and business owners who catered to the mill workers.

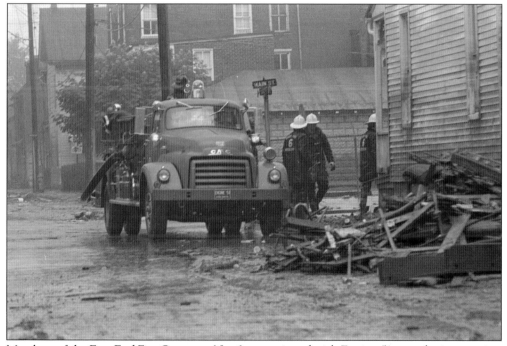

Members of the East End Fire Company No. 6 are stationed with Engine 51 near the intersection of Main and Trewick Streets in the West End.

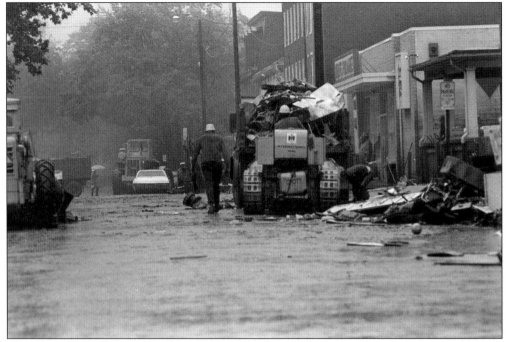

This is another view of the mass cleanup in the West End, in this case along the 200 block of Main Street near Dundoff's Food Market.

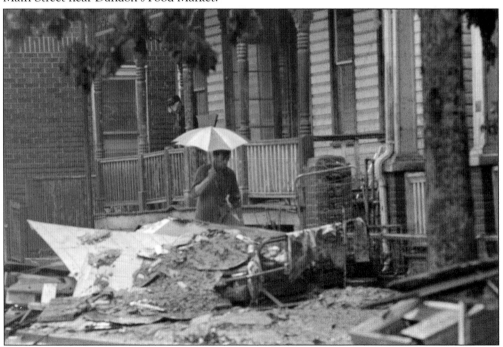

This closer view of Main Street shows some of the immediate damage caused by Agnes in the West End. The little that was salvageable and not left piled up on the sidewalks served as a reminder for those who used to call the West End home, as over the next few years, the homes were demolished and the rubble was removed until eventually there was nothing left of the neighborhood.

Three
HARRISBURG AND
PAXTON CREEK

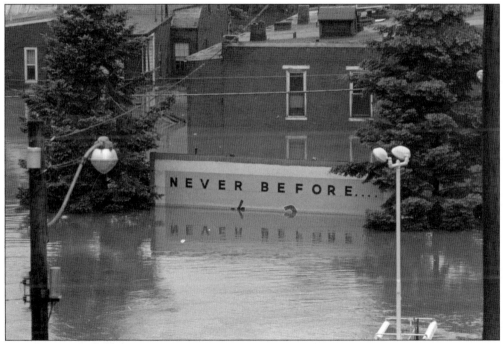

On the morning of June 22, Paxton Creek, fueled by unusually heavy rains, transformed from a small tranquil stream into a raging river, exploding through the industrial and residential sections near Cameron Street in Harrisburg. Here, at the Red Head gas station on South Cameron Street, only the top of a billboard is visible above the floodwaters. Interestingly, it manages to sum up the surrounding conditions perfectly.

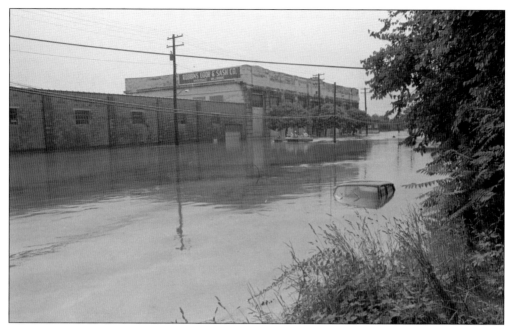

Patrol boats glide past the Robbins Door and Sash Company on South Cameron Street in Harrisburg. Paxton Creek is located directly behind the Robbins building and provided the first round of flooding in this area. Later, as the Susquehanna River continued to rise, it would exacerbate the problem.

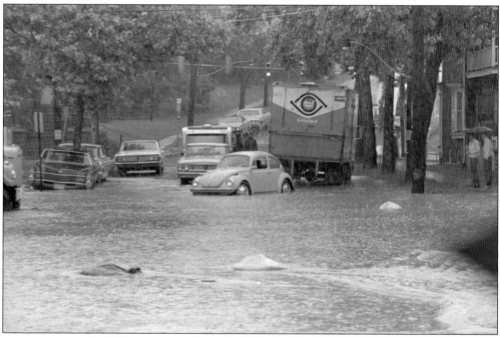

A moving van pulls a Volkswagen Beetle out from the floodwaters of Sycamore Street just below the intersection with Cameron Street. This portion of Sycamore Street now serves as a thoroughfare to the PennDot building on the riverfront. However, before Agnes, Sycamore Street led back to the South Ninth Street neighborhood, which was part of Shipoke.

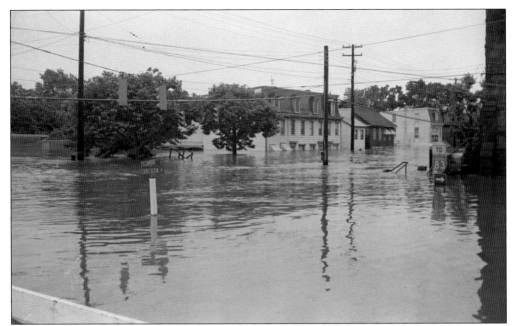

The following day, the scene at the intersection of Cameron and Sycamore Streets had changed drastically. The rain had stopped, but the floodwater had risen up to the crosswalk lights and nearly to the second floor of the homes and businesses lining Cameron Street. This photograph was taken from the parking lot of Acme Markets.

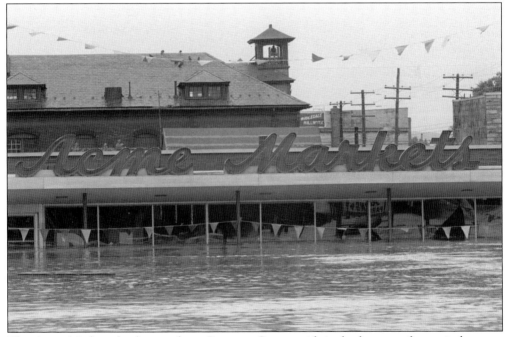

The Acme Markets food store along Cameron Street, with its broken storefront window, was also a casualty of the floodwaters. The location was later renovated by Harrisburg River Rescue, and it continues to serve as their headquarters. In the background is the abandoned firehouse of Susquehanna Fire Company No. 9.

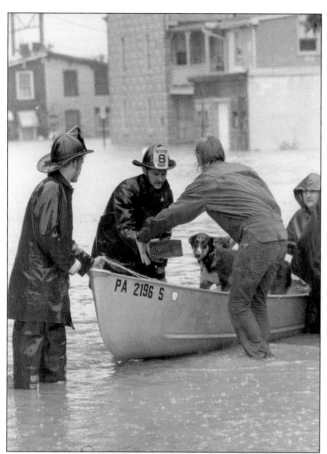

As the heaviest rains fell—more than nine inches on June 22 alone—the South Ninth Street section of Shipoke was one of the first areas to be evacuated. Members of the Mt. Pleasant Fire Company No. 8 assisted with the evacuation of these Shipoke residents, removing them from harm's way and to the slightly higher ground on Sycamore Street.

From the vantage point below on Sycamore Street, looking back towards South Ninth Street, residents are evacuated by boat as rescuers wade through chest-deep water outside of Suzic's Hotel. Former resident Mary Ellen Kindness recalled that when they made the decision to evacuate their South Ninth Street home, the water was pouring into the basement like a waterfall; when they finally had packed and left, the water had risen up to the floorboards.

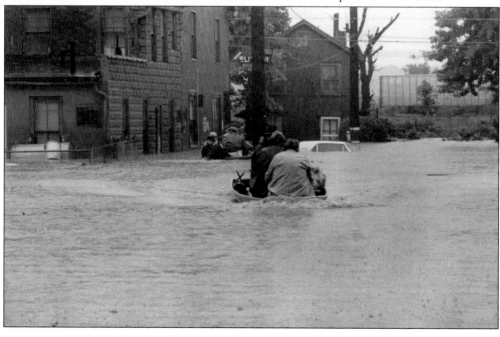

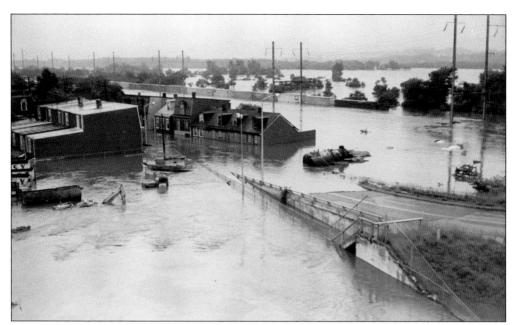

The Susquehanna River rises above the railroad embankment to meet Paxton Creek in the South Ninth Street section of Shipoke. In the foreground, the "new" Dock Street Bridge descends down onto Ninth Street, where the floodwaters have nearly reached second-story windows. In the background, behind the line of boxcars, is the area where PennDot would relocate to in the 1990s.

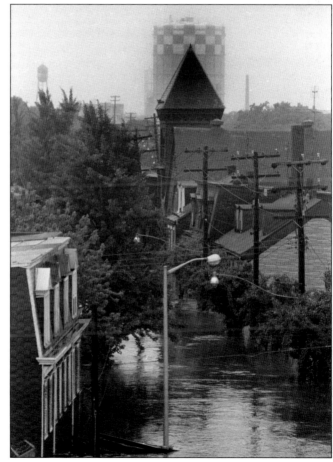

This slightly different view of South Ninth Street shows not only the flooded homes, but also the intimate nature of the neighborhood. Trinity Lutheran Church, with its steeple rising above the treetops, was nestled in the center of the Shipoke community.

61

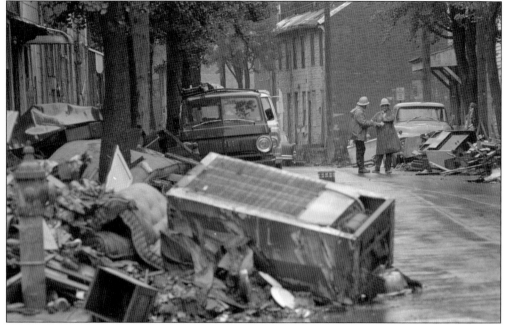

Debris and household items damaged by floodwaters are piled haphazardly outside the homes along South Ninth Street in Shipoke. The wooden overhang on the right was part of the storefront of Goldie's Grocery. Soon after the floodwaters disappeared, these homes and businesses were posted with notices that they were no longer fit for human habitation. The neighborhood was razed soon afterwards.

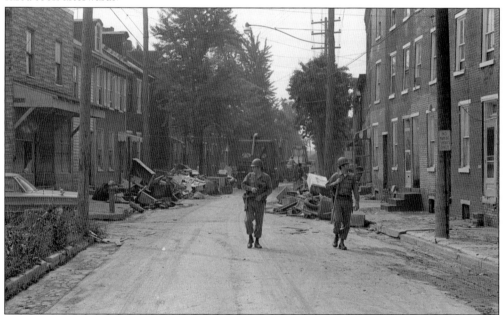

National Guardsmen, armed with rifles and batons, patrol South Ninth Street to protect against looting in the already abandoned neighborhood. Behind them, crews work to remove the damaged contents of the homes that were tossed into the street. As a point of reference, Goldie's Grocery is on the left next to Lehr Street (Alley).

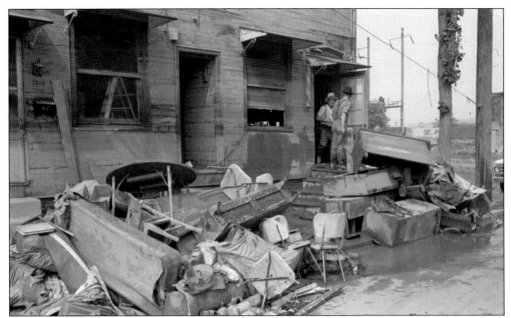

Two Mennonite gentlemen remove items from the barbershop of George W. Hare at 1014 Ninth Street. Hare passed away in February of that year, but his daughter Mary Ellen Kindness still lived next door at 1016 South Ninth Street at the time of the flood. Despite the presence of the National Guardsmen, the wooden barber pole was stolen from the house not long after this photograph was taken.

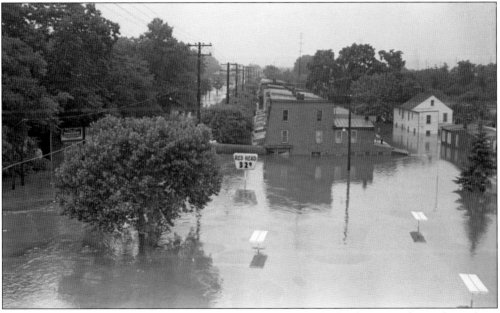

Taken from the raised elevation of Interstate 83, this view looks down on the Red Head gas station at the corner of Hemlock and South Cameron Streets. A storage tank has wedged itself between the Wonder Bar, at 1000 South Cameron, and a telephone pole. All of the homes and businesses seen here along South Cameron Street and the few behind them on Salmon Street have been removed.

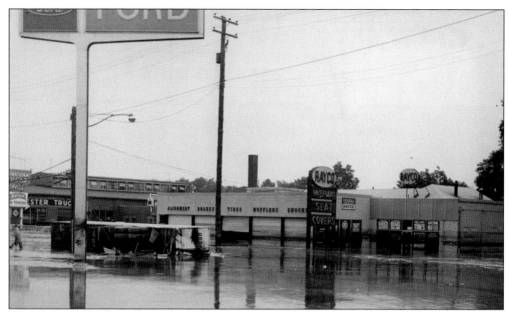

A truck trailer, picked up by floodwaters from the Hershey's Ice Cream plant, comes to rest several blocks "downstream," between the Francis Ford and Rayco dealerships at the corner of Cameron and Paxton Streets.

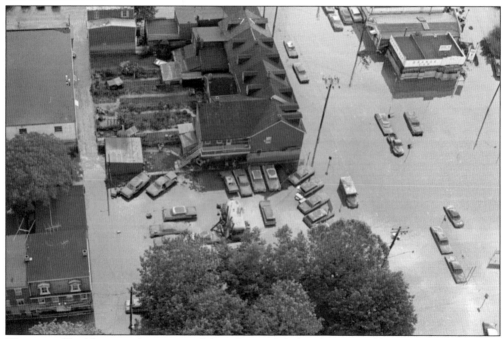

The row of buildings in the center of this photograph faced out to Old Paxton Street. Tony's Lunch, which served the notable Cho-Cho malted ice creams, was in the building at the top of the row, at 1024 Paxton Street. The proprietor, Tony Spagnolo, received a call on the morning of June 22 from the owner of a neighboring business telling him that a three-foot wall of water had just crashed down through Cameron Street and to not bother adventuring into the neighborhood. Only 30 days later, the building was condemned.

This photograph was taken from the old Lebanon Valley Railroad Bridge that crosses Cameron Street near Berryhill Street. The backs of the homes on the left side of this photograph front onto a portion of Berryhill Street that no longer exists. The same is true of the homes to the right and center, which were located on South Tenth Street, with Paxton Creek behind them. After the removal of the buildings, the site became part of the parking lot for the automobile dealership at Cameron and Paxton Streets.

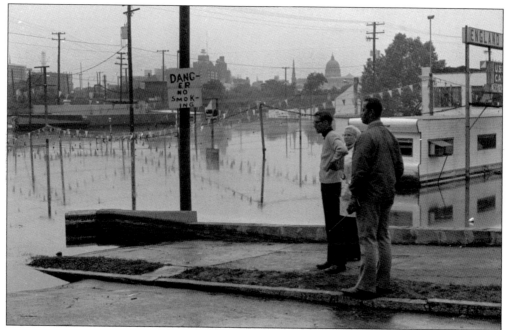

Harrisburg mayor Harold Swenson, his wife, Elsie, and constable Ed Watson survey the landscape from the higher ground of Berryhill Street near England Motors, off Cameron Street. During the crisis, the mayor conducted a tour of the city every three hours.

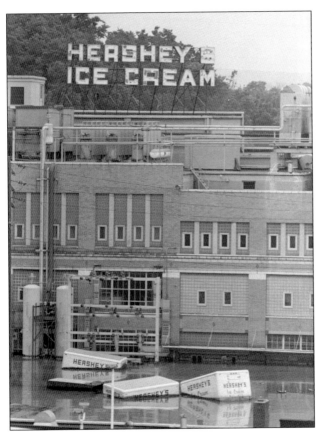

The insulated construction of the Hershey's Ice Cream refrigerator trucks allowed them to float in the floodwaters on Cameron Street. The Hershey's plant, like all of the other businesses along Cameron Street, had to deal with the cleanup of debris. But unlike the other businesses dealing with the cleanup of mud, oil, and sewage, Hershey's had the added problem of sanitizing and sterilizing the buildings and equipment in order to ensure a safe product for public consumption.

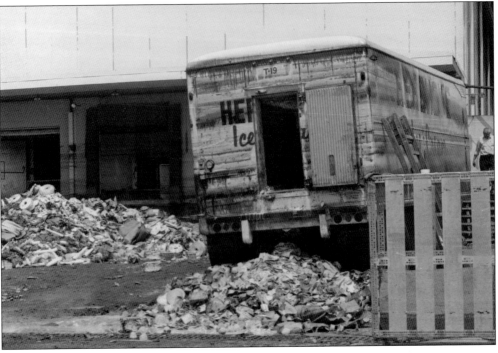

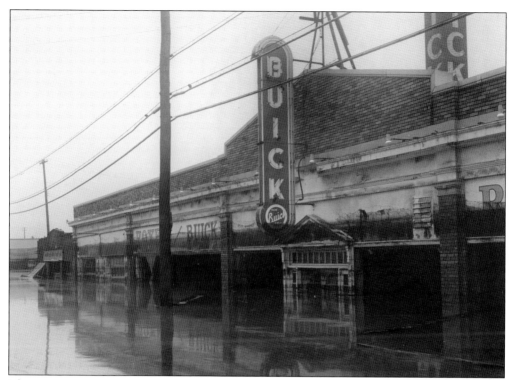

The Royer Buick-Opel dealership at 218 South Cameron Street lost more than 140 new and used cars to the flood. More than 10 feet of water entered the dealership showroom and offices when the large glass display windows were smashed in by the rush of floodwaters and debris. The dealership left Cameron Street not long after the floodwaters did. Before the flood, the dealership had already planned to leave Cameron Street, having already broken ground at a new location on Chambers Hill Road.

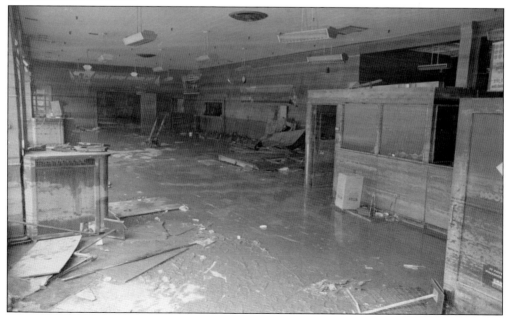

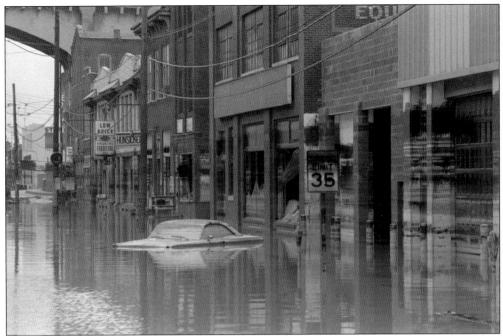

Here are two views of the same location near the Mulberry Street Bridge along South Cameron Street. The above image shows the black striated lines left behind by the layer of oil that swirled on top of the floodwater as it slowly receded. Hunsicker's motorcycle dealership is on the right with a Harley-Davidson sign in the front of the establishment. The photograph below shows the damage to the inventory of a furniture store, which has been pushed out to the curb. Of course, no Harleys from Hunsicker's made it to the curb. Or, if they had, they were long gone by the time this photograph was taken.

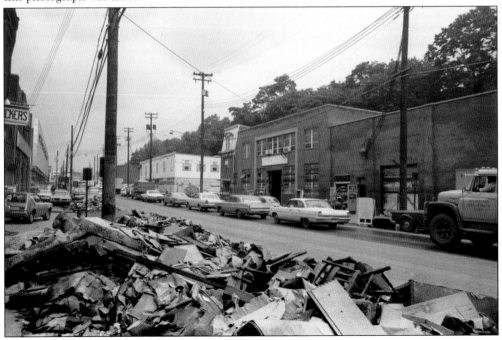

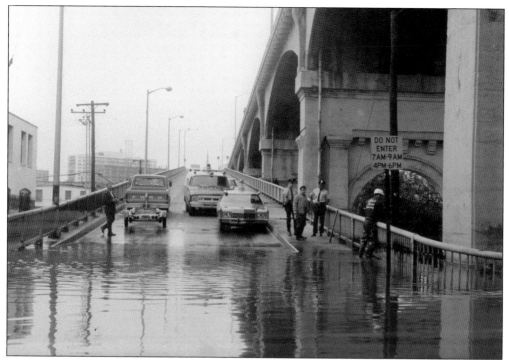

The entry ramp to the Mulberry Street Bridge served as a boat launch and point of access for Cameron Street. This photograph was taken after the waters had already receded about six feet, with the high-water level marked in oil on the light pole and on the bridge's guardrail.

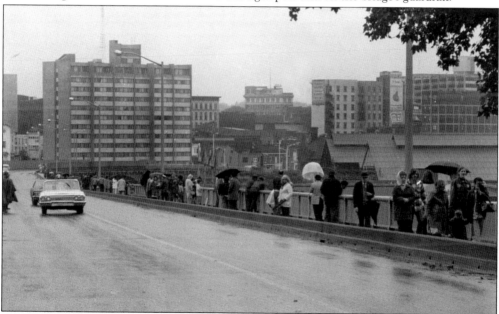

Spectators line the Mulberry Street Bridge, which provided a safe vantage point to view the flood taking place below on Cameron Street. Although the elevated site provided safety from the floodwaters, it did not erase the smell of oil, garbage, and raw sewage. The woman on the far right covers her face with her coat in order to shield herself from the odor.

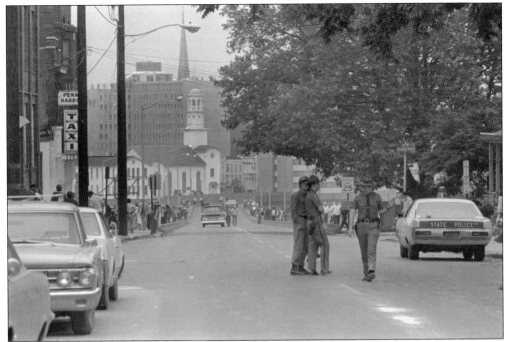

State police officers and National Guard members coordinate their efforts at the checkpoint on Allison Hill, near the entrance to the Mulberry Street Bridge. The checkpoints were designed to limit unnecessary automobile traffic entering the downtown areas.

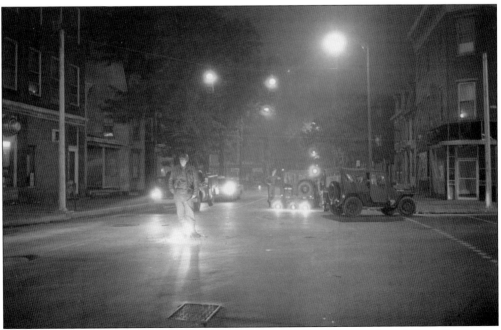

This is a nighttime view of the checkpoint on Allison Hill at Thirteenth and Derry Streets. In addition to monitoring the traffic entering into the city, the National Guard was also charged with enforcing the 7:00 p.m. to 7:00 a.m. curfew put into place by Mayor Swenson's office.

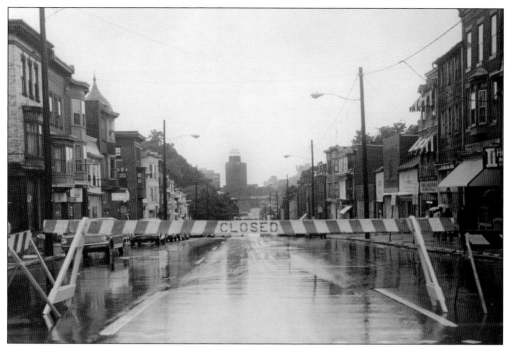

As part of the ban on nonessential traffic, Market Street was closed at Thirteenth Street on an around-the-clock basis beginning on June 23. This restriction stayed in effect for several days after the floodwaters receded so that cleanup personnel would be able to work without the problems of downtown traffic and sightseers.

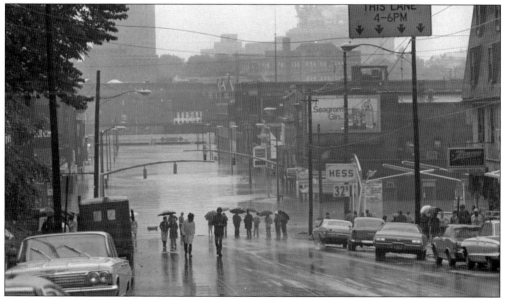

Prior to the nightly curfews and the restriction on motor vehicle traffic, the intersection of Market and Cameron Streets became a popular destination to view Paxton Creek rushing through the city streets. But it was also one of the most dangerous areas in the city, as it became necessary for emergency crews to rescue the individuals who lived and worked in the path of the swiftly moving floodwater.

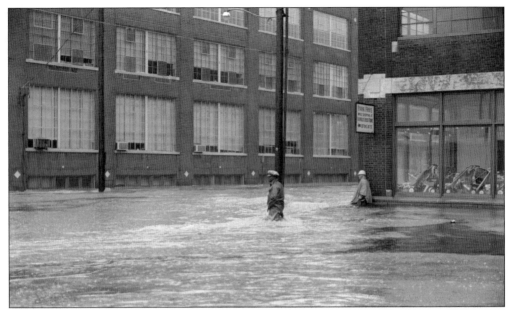

City police and emergency personnel stand watch outside of Schell's Seeds & Farm Implements on Market Street as the floodwaters from Paxton Creek rush past them down Tenth Street. Under normal circumstances, Paxton Creek is no more than 10 feet across and one foot deep, running south between Cameron and Tenth Streets. By the afternoon of June 22, the creek had expanded outward to cover the area between Ninth and Cameron Streets.

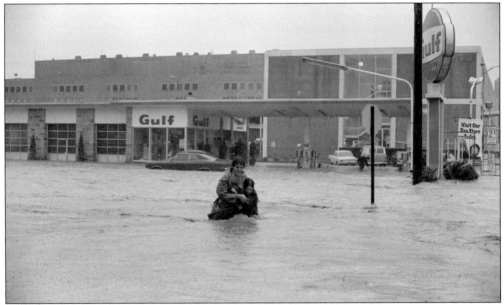

When Bob Woodward arrived at the *Patriot-News* to pick up his wife, Nance, on the morning of June 22, the water racing down Tenth Street did not even cover his boots. Nance balked at the idea of leaving, as the conditions outside did not appear to be terribly bad. By the time they left the building and tried to cross back over Tenth Street, the scene had changed greatly (seen here), with much deeper water and a swift current. Nance recalled the need to hold on to her husband as her feet were swept out from underneath her.

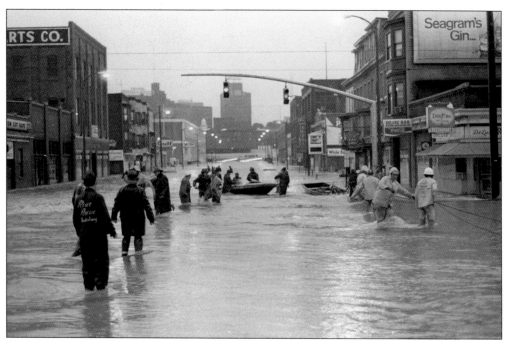

At the intersection of Market and Cameron Streets, a collective rescue effort was undertaken by members of the Harrisburg City Fire and Police Departments, Harrisburg River Rescue, and the Coast Guard. While there have always been a number of businesses in the vicinity of Market Street between the subway and Cameron Street, in 1972 a considerable number of people also resided in the area. Due to the impassable nature of the floodwaters, the decision was made to evacuate the area. The rescue efforts on the whole were successful, but unfortunately, the dangerous conditions resulted in losses of life.

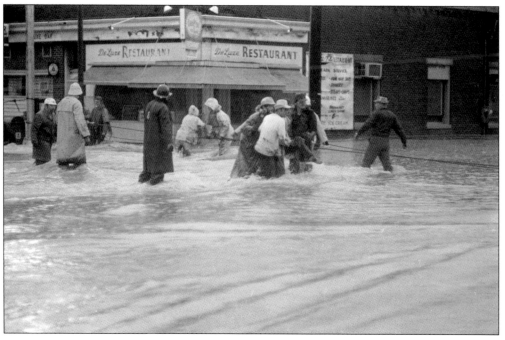

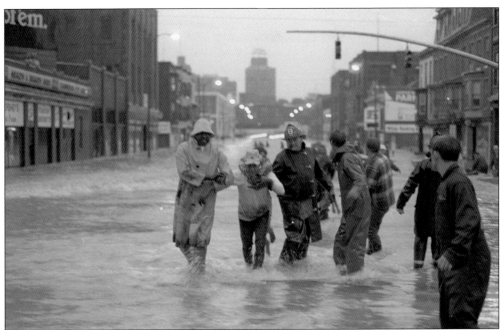

On Thursday evening, June 22, the conditions had deteriorated considerably on Market Street. At the *Patriot-News* offices, floodwaters reached up to the first-floor windows. Against her better judgment, Emma Parker (not pictured here), an operator working at the newspaper for 30 years, climbed into a river rescue boat along with reporter Clyde Shue. Her intense fear of the boat, along with the rushing floodwaters, undoubtedly contributed toward the capsizing of the boat. She, along with the others, fell into the raging floodwaters. Several days later, her body was found a short distance downstream. Shue was carried by the current across Market Street into the parking lot of the post office building, where he managed to cling to the axle of a truck until Harrisburg River Rescue could return to rescue him.

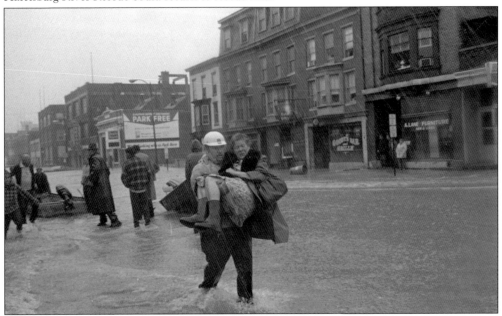

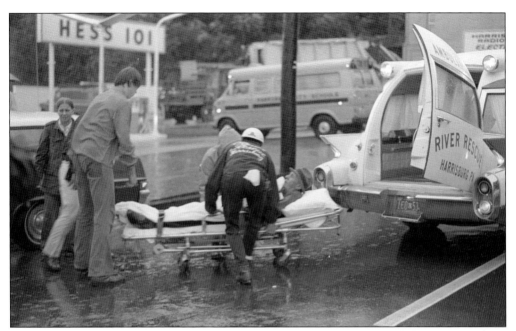

An elderly gentleman evacuated from Paxton Creek's flood zone is attended to by Harrisburg River Rescue on the upslope of Market Street, above Cameron Street. On June 23, Paxton Creek's floodwaters claimed one additional life when a rowboat carrying three men capsized on the 500 block of North Cameron Street. Joseph Taylor of Steelton was found three days later, when the waters eventually receded, four blocks to the south.

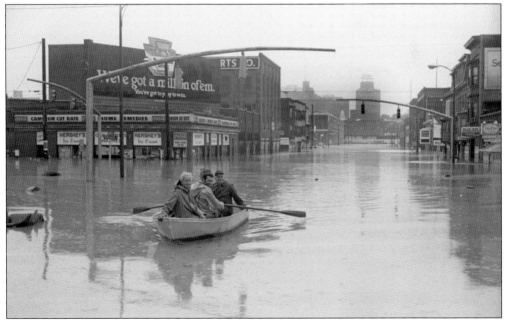

In this photograph, a light rain is still falling on June 23. The rapid currents of Paxton Creek have slowed and the intersection of Cameron and Market Streets resembles a calm lake rather than the roaring river it was the day before. Across this calm, a rowboat carrying the maintenance men from the *Patriot-News* building glides through the intersection towards higher ground.

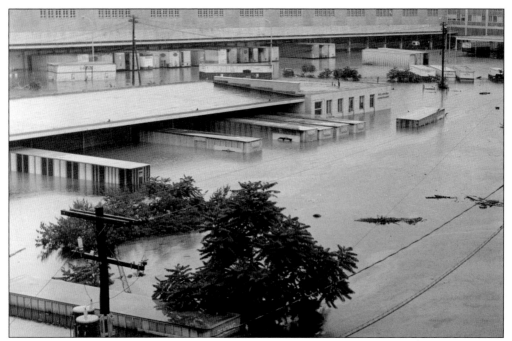

This photograph was taken from the Mulberry Street Bridge, above Tenth Street, while the rain was still falling on June 23. In the background, many of the mail trailers belonging to the post office remain stranded at the loading docks. In the foreground, where the water is deeper, trailers at the trucking terminal for the Reading Company are almost completely submerged.

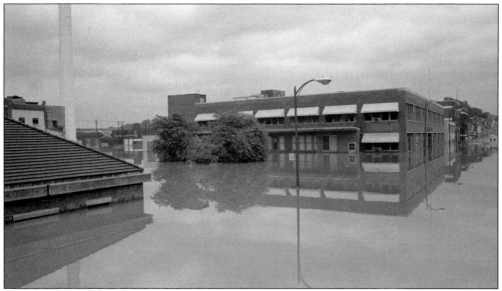

Along Market Street, floodwaters from Paxton Creek reached between eight and nine feet at the *Patriot-News*, flooding the basement pressrooms and the offices on the first floor. The building in the left foreground is a sewage-pumping station. On June 29, after the floodwaters had receded, city workers entered the building to clean and restart the gas engines that drove the station's pumps. Gas fumes, which had collected and remained in the building, were ignited from a spark caused by the engine's batteries, burning all four workers and killing three.

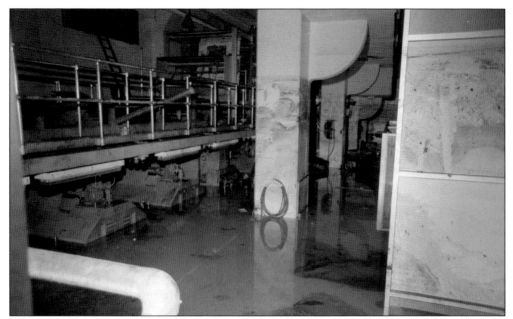

The pressroom at the *Patriot-News*, seen here still partially submerged, was inoperable by Thursday afternoon, June 22, as pumps could not keep up with the water entering the lower level of the building. As a result, the Thursday evening news edition could not be printed, and for the first time in 120 years, an edition did not make it to press.

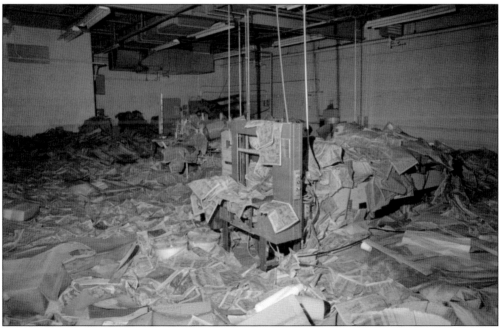

Sheets of wet newsprint blanket the floor and machinery in the dispatch room at the *Patriot-News*. After operations were halted on June 22 at the main offices on Market Street, it was not until June 28 that another edition of the paper was printed. That edition, which sported a bold red banner exclaiming, "The Anatomy of a Disaster," was printed with the aid of the *Allentown Call-Chronicle*, and for many, it provided the first glimpse of the wide extent of the damage caused by Agnes.

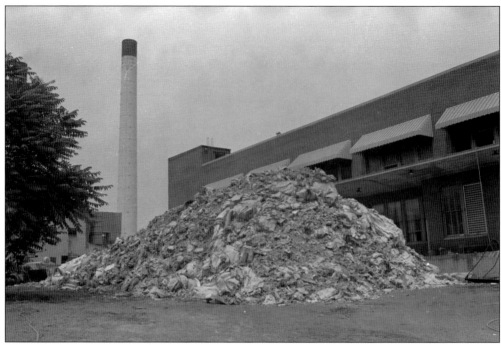

Next to the *Patriot-News*'s loading docks, a mountain of waterlogged newsprint is piled higher than the first story of the building and extends nearly as long as the building's length.

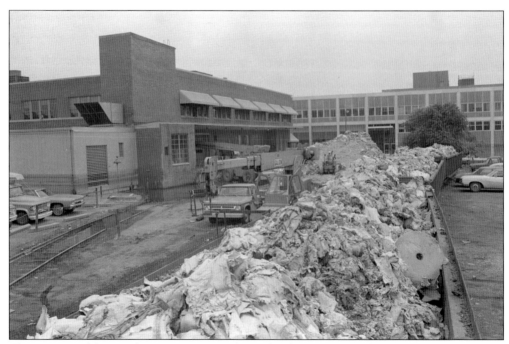

The amount of damaged newsprint was so large that heavy pieces of construction equipment, including bulldozers, were required to manipulate and move the mountain of paper. The debris was then loaded onto open gondola railroad cars by cranes using large bucket attachments.

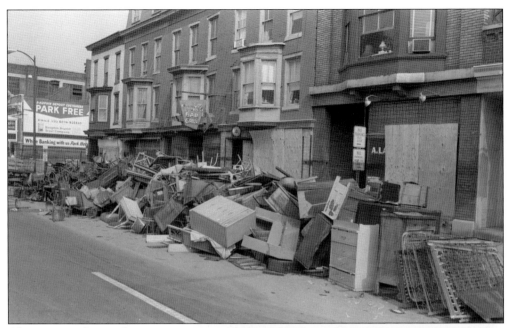

Above, water-damaged furniture is stacked along the 1000 block of Market Street, mostly the inventory of the A. Lane and Max Smeltz furniture stores, which were located there at the time. This entire row of businesses and dwellings is no longer standing.

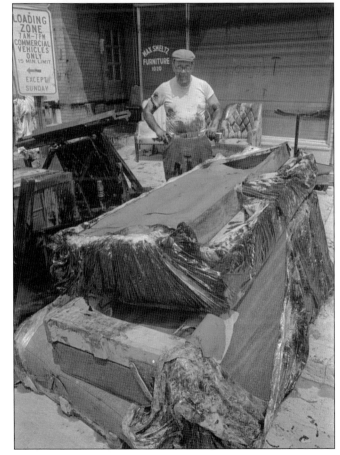

Here, covered in the same oily grime that coats the furniture along the side of Market Street, is presumably Max Smeltz, who pauses from his work to speak with the photographer.

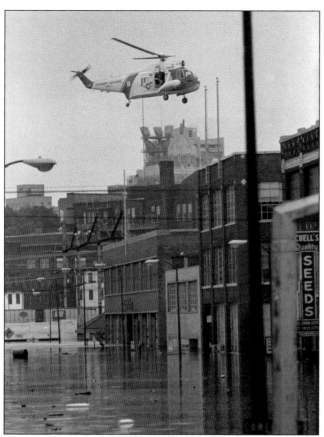

Fitted with a rescue basket, a Coast Guard helicopter hovers over Market Street, searching for anyone left stranded by the floodwaters. The helicopter is a Sikorsky HH-52A Sea Guardian, registration number 1398. This particular helicopter performed search-and-rescue missions not only in the city, but also along the Susquehanna River, with one mission at Pole Island near Marietta.

Below, with the shadow of the state capitol dome in the background, a lone emergency worker rows out into the middle of Cameron Street during the driving rain on June 22. While the boat seems out of place in this city setting, the true irony of the image is that neither the gas station nor the auto parts store is of any use on the flooded street.

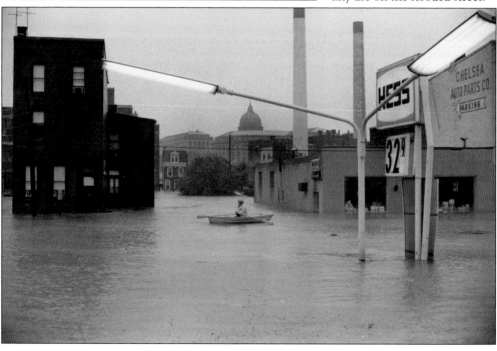

This is a group shot of the self-described "Harrisburg Seven," who were responsible for covering the flood in the Harrisburg area for Allied Pix Services, Inc. Their output for the Agnes flood resulted in nearly 3,000 photographs, documenting events throughout the Susquehanna Valley. They are, from left to right, (kneeling) Ronald Coleman, Dennis Nye, and Francis V. Smith; (standing) Thomas Leask, Norman Arnold, Pete Rekus, and Jim Bradley.

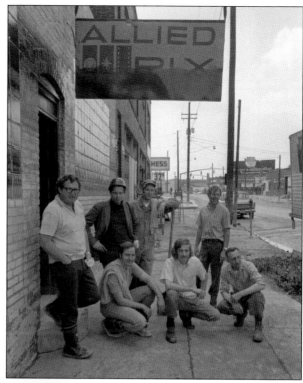

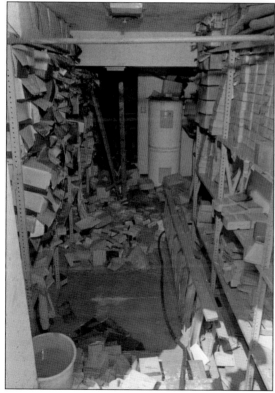

As the backdoor to the Allied Pix office is opened for the first time after the flood, a quick glimpse reveals extensive damage to the boxes of photographic negatives housed there. The vast majority of the negatives dating from 1952 up to the flood were unsalvageable and ultimately lost. The surviving negatives are currently housed at the Historical Society of Dauphin County.

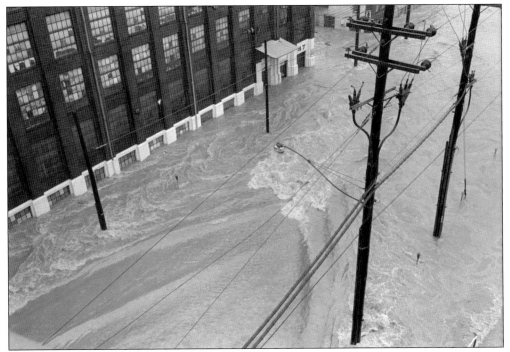

This view of Cameron Street taken from the safe vantage point of the State Street Bridge shows the force of the floodwaters as they rush past the Cameron Dress Shop.

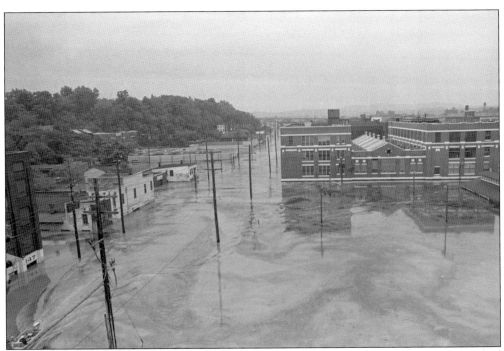

In this similar view of Cameron Street, the current has slowed as the floodwaters have reached their crest. The surface of the water is coated with a skin of oil, which swirls wildly when the motorboat passes through and breaks the calm of the drifting current.

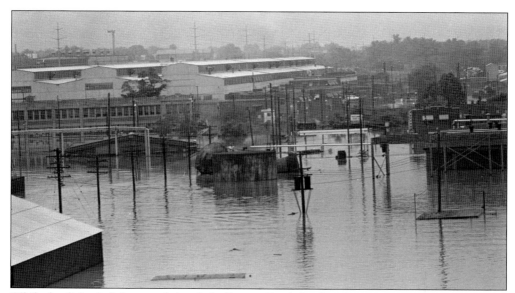

While the slick of oil that traveled with the Paxton Creek floodwaters came from several sources, the largest source was the collapse of oil tanks on the grounds of Harrisburg Steel. This photograph shows that at least two storage tanks collapsed, one to either side of the larger tank in the front. The Sanborn maps of that era indicate that each of these tanks had a capacity of 25,000 gallons of oil.

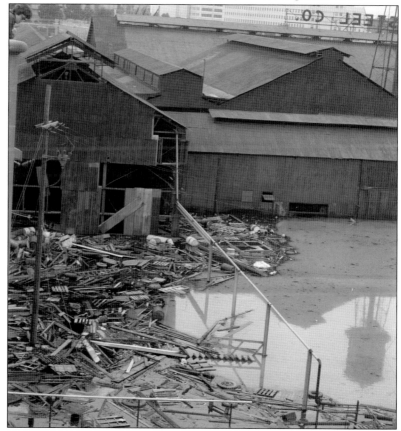

It was not only oil that was floating free at the Harrisburg Steel plant, but also anything that was not either fastened or securely tied down. Here, this random assortment of objects has collected against the State Street Bridge.

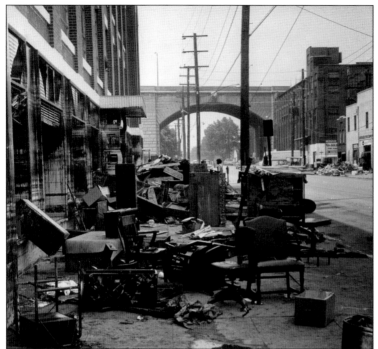

Office furniture and equipment are tossed out of the already broken windows of the Central Industrial Building, at 100 North Cameron Street. Located on the south side of the State Street Bridge, "downstream" from Harrisburg Steel, the first floor of this wide office building was coated inside and out with oil.

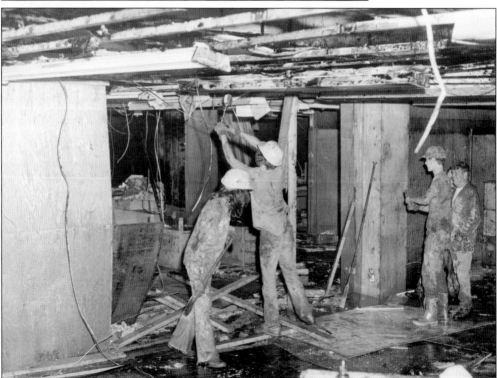

With the initial force of the rushing waters breaking out most of the windows of the building, the oil covered almost everything, from top to bottom, on the first floor. From the wiring in the ceiling all the way down to the floor coverings, the entire first floor of the building was gutted.

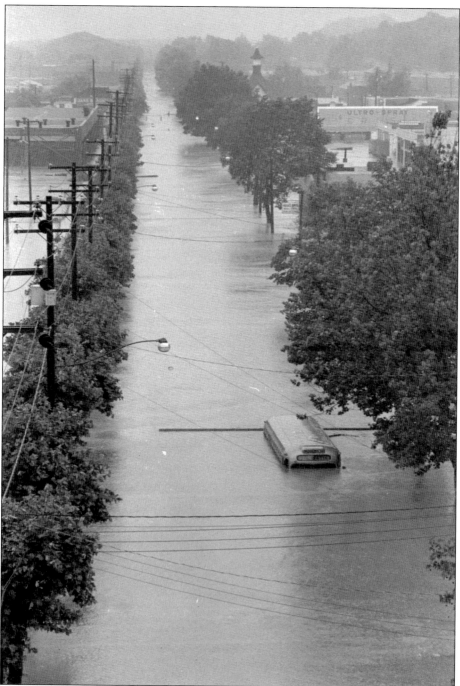

Floodwaters aside, the appearance of trees lining Cameron Street in this view, looking north from the State Street Bridge, gives the thoroughfare a much different appearance than it has today. A Harrisburg Railways Company bus is left stranded in the middle of Cameron Street, less than a block from the company's headquarters, on the right side of the street. In the distance is the familiar church and steeple, which at the time belonged to the congregation of the Bethany African Methodist Episcopal Zion Church.

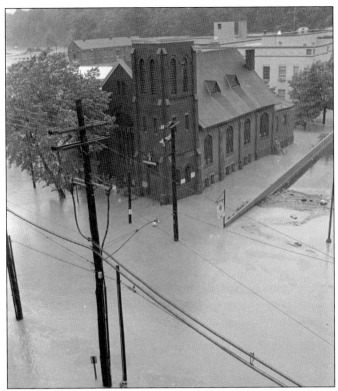

The Lingo Temple Church of God, as it was known at the time, was on Cameron Street next to the access ramp to the State Street Bridge. The church and congregation took its name from Elder Ernest T. Lingo. The church building was constructed around 1907 and was first home to the congregation of St. Paul's Baptist Church.

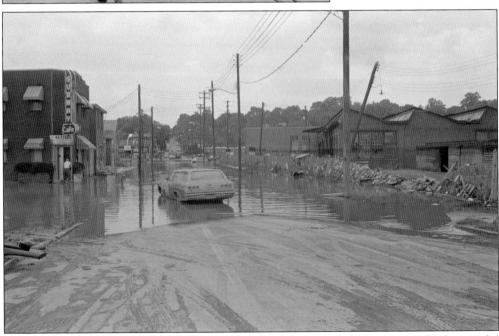

Along Herr Street, the cleanup process begins at the Subway Café. While the establishment did receive its share of water and mud on the interior, the exterior of the building appears to have avoided any significant damage. The same, unfortunately, cannot be said for the fence bordering the Harrisburg Steel Plant, which served as a filter for floating debris.

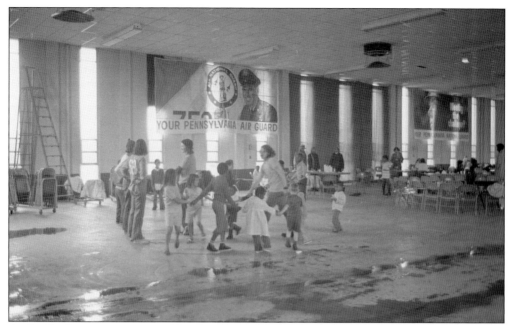

As the floodwaters rose to record heights in Harrisburg and the surrounding communities, schools, churches, public buildings, and private homes were opened as places of refuge for those who were evacuated and unable to obtain accommodations with family or friends. Here, Agnes is temporarily forgotten by children engaged in play at the National Guard Armory Center.

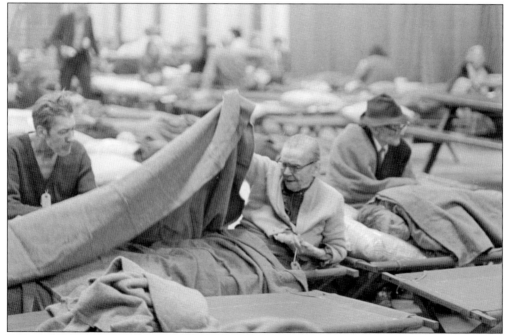

Each individual who came to the National Guard Armory Center was given an identification tag that was worn throughout their stay. The living quarters, while better than the alternative outside, were less than ideal and provided little to no privacy. One woman described her short stay at the armory as being chaotic and disturbing.

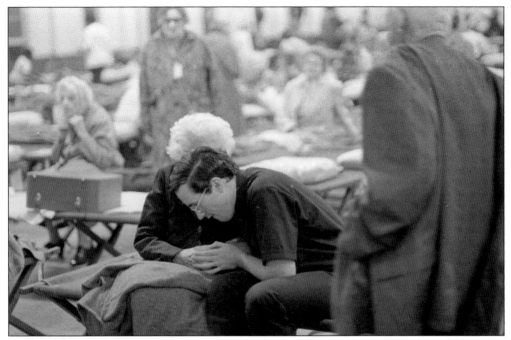

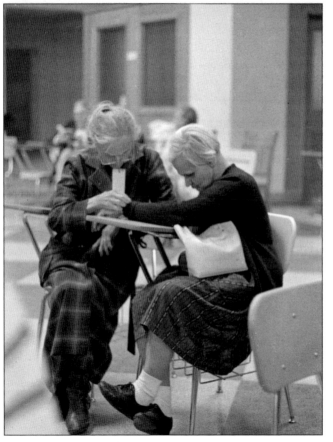

Above, a member of the clergy provides a listening ear to the weary and distressed. At left, two women offer a moment of consolation to each other. Those who entered into the shelters did so filled with the uncertainty of what they might face upon their return home. The shelter at the armory was described by another individual as being filled with the sounds of agony and despair. Crying could be heard throughout the night, from children who were forced into this strange place and from the elderly who had more than likely lost their homes and a lifetime of possessions.

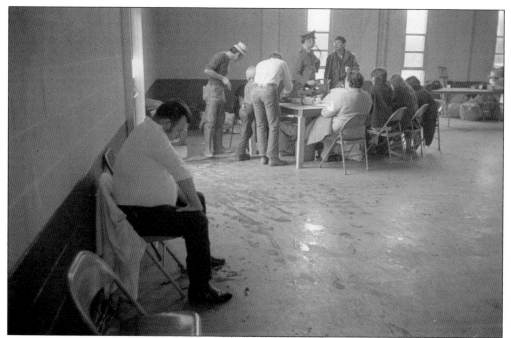

A volunteer at the National Guard Armory Center takes a moment to catch his breath. Between 5,000 and 6,000 area residents were displaced by the flood and forced to seek refuge in the many public shelters and private homes.

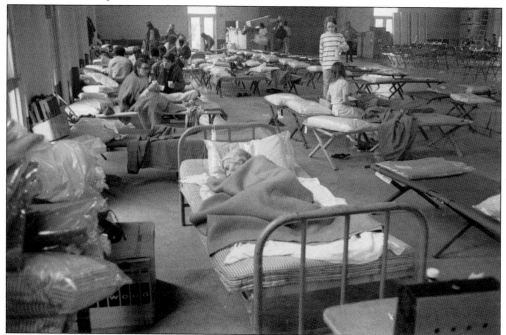

An elderly woman is given a moment to rest and momentarily forget what may await her when, or if, she returns home. While federally subsidized flood insurance was made available to residents of Harrisburg, Steelton, and Susquehanna Township prior to Agnes's arrival, there were a total of only five policyholders in those three municipalities.

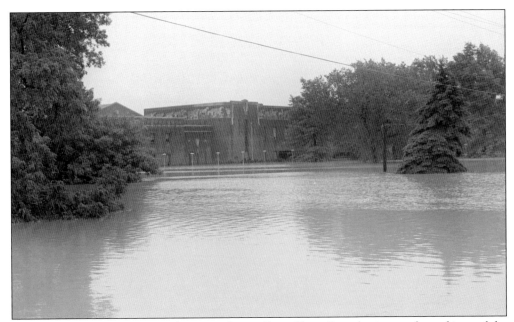

The Maclay Street entrance to the Pennsylvania Farm Show Complex is transformed into a lake by nearby Paxton Creek. The building complex is also home to the Farm Show Arena, which served as a venue for well-known musical acts and attractions. On June 23, Johnny Cash, along with June Carter and the Carter Family, were scheduled to perform at the arena. The show was rescheduled for later that summer on August 11.

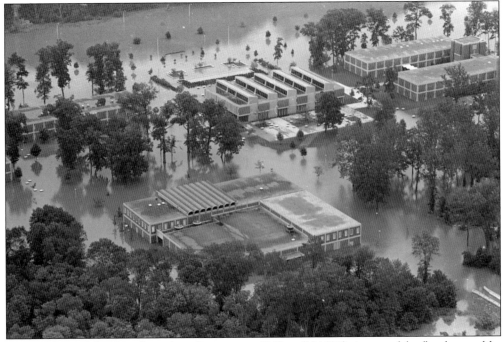

The buildings of the Harrisburg Area Community College (HACC) rise out of the floodwaters like islands in the small ocean created by Paxton Creek. In the foreground is the Cooper Student Center, with Blocker Hall, McCormick Library, and Whitaker Hall behind it, from left to right.

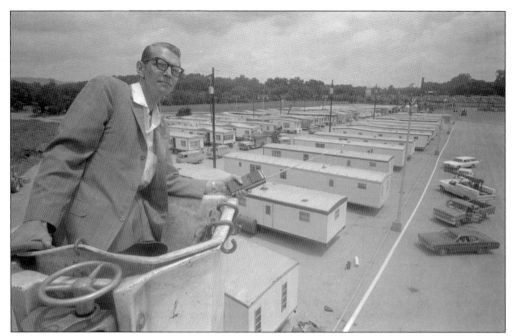

Mayor Harold Swenson surveys the view from above "Harris Haven North," a temporary neighborhood of trailers for displaced flood victims set up in the parking lot of the Pennsylvania Farm Show Complex. The trailers were provided rent-free to city residents who qualified and came complete with hookups for utilities, sewage, and running water.

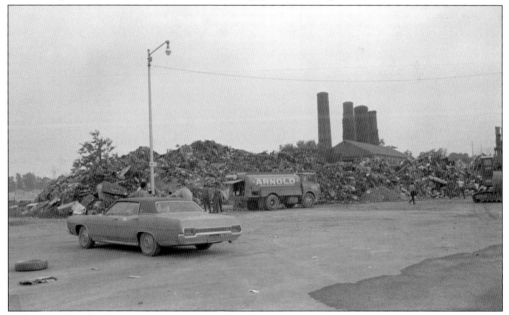

Following the flood, a massive cleanup effort by city workers and contractors was required to clear the debris that lined the city streets. A decision was made to transport this debris to the Pennsylvania Farm Show Complex parking lot, where it soon piled up into one large mountain of trash. An oil truck was then brought in to provide some assistance removing the trash from the site.

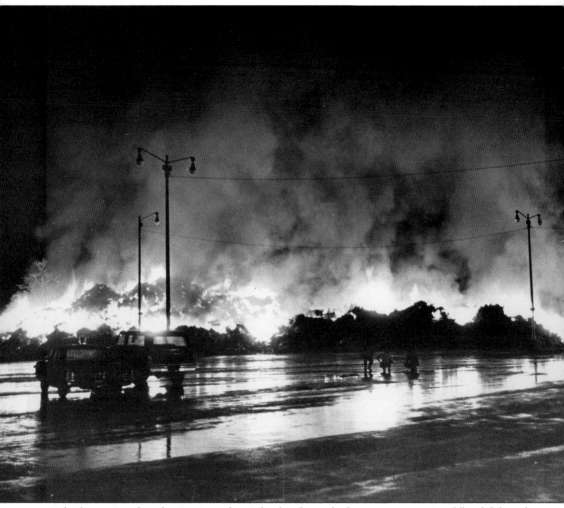

A thick curtain of smoke rises into the night sky above the burning mountain of flood debris that was collected from the city streets. From this vantage point, the spectacle is taken in by only a few bystanders brave enough to withstand the heat and noxious fumes emitted by the blaze.

Four
HARRISBURG AND THE SUSQUEHANNA RIVER

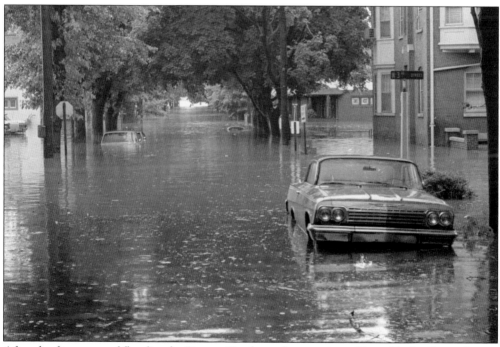

After the first stage of flooding by Paxton Creek on the morning of June 22, the Susquehanna River reached the 17-foot flood stage that same afternoon. From there, conditions rapidly changed, with the river rising nearly one foot per hour over the next 11 hours. By the morning of Friday, June 23, the river stage was over 30 feet and large portions of the riverfront were below six feet of water. Here, in the midtown portion of the city, the river has reached up past Third Street on Woodbine Avenue.

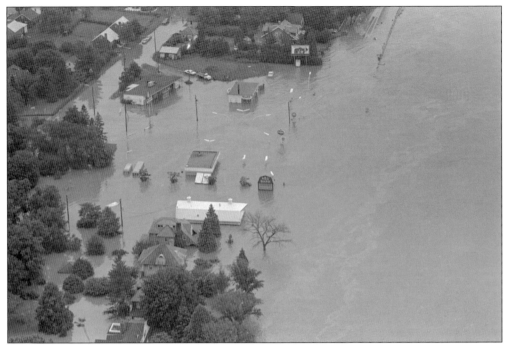

This aerial view of North Front Street shows the Susquehanna River so high that the Red Barn Restaurant and the surrounding businesses appear to be out in the river itself.

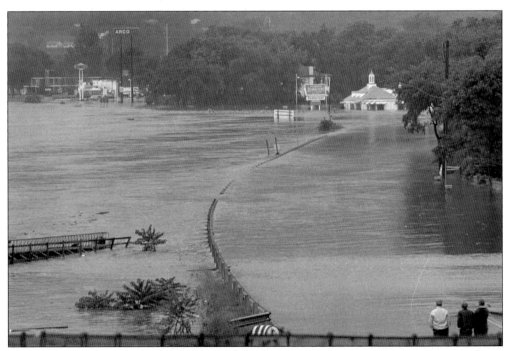

This view, taken from the George Wade Bridge, which was under construction at the time, shows the Susquehanna River up over its banks and into the parking lot of Howard Johnson's in the 4000 block of North Front Street.

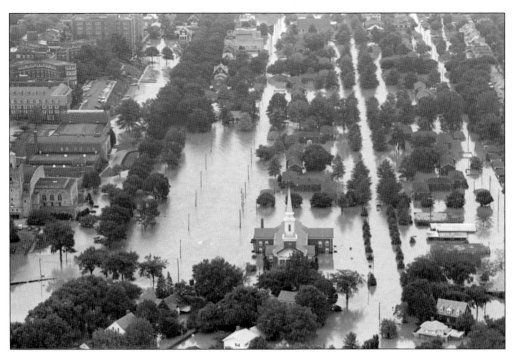

The aerial view of North Harrisburg above shows how far the Susquehanna River extended back into the city in the vicinity of Division Street. Polyclinic Hospital, in the upper left corner, was built on a higher rise of land and appears to have stayed above the floodwaters, but the complex did experience flooding in its basement level.

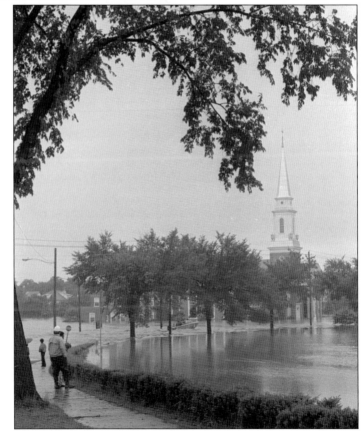

Fed by the floodwaters, Italian Lake rises out of its normal confines and threatens to spill over onto North Third Street. In the background, a boat races down the rapids of Division Street near Lakeside Lutheran Church, as it was known at the time, searching for stranded city residents.

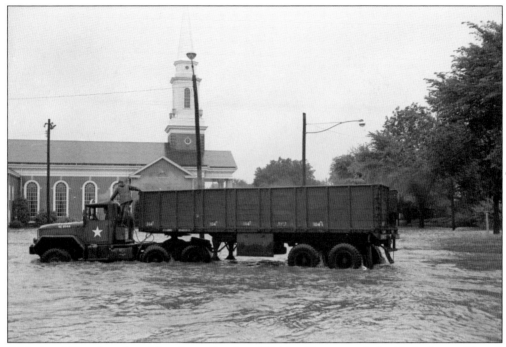

A National Guard truck positions its trailer along Division Street near Lakeside Lutheran Church to prepare to evacuate residents who were stranded in their North Harrisburg neighborhoods.

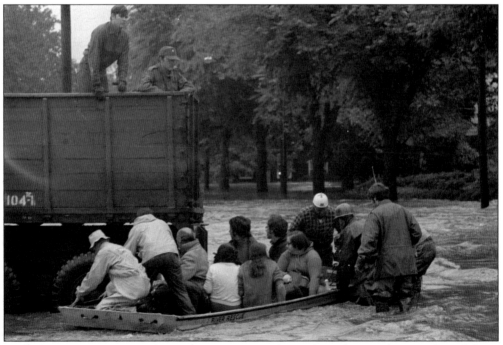

With the assistance of Harrisburg River Rescue, residents of North Harrisburg are ferried down Division Street and loaded on to a National Guard transport truck to be taken out of the flood zone.

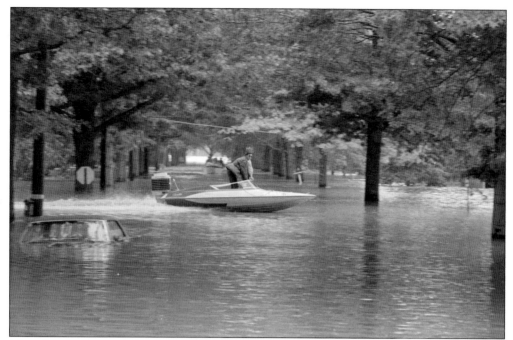

More than likely out for a thrill, a speedboat races up North Third Street through the residential neighborhoods of midtown Harrisburg. The hazard in this, of course, was the danger of hitting partially submerged street signs and automobiles, like the one in the foreground.

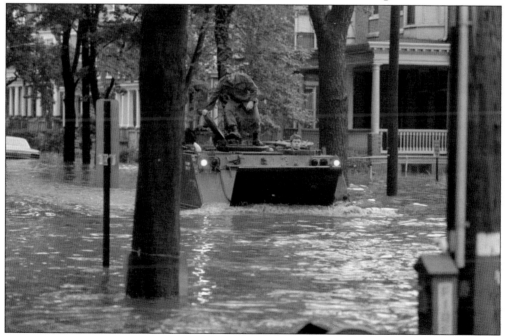

National Guardsmen approach the corner of North Third and Woodbine Streets in an M113 armored personnel carrier. Obviously not used here for combat purposes, the vehicle was equipped with tracks and had amphibious capabilities that allowed it to move without the worry of unseen obstacles hidden beneath the floodwaters.

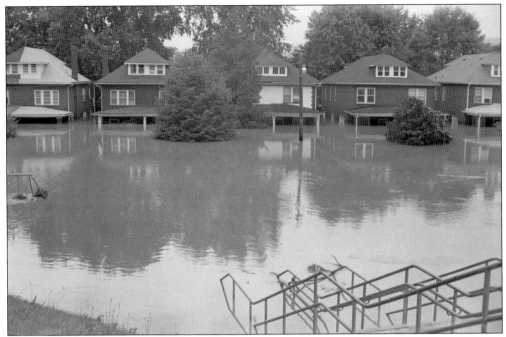

The steps of the Riverside School lead down to the flooded 3900 block of Green Street. Even here, four blocks from the Susquehanna River, the floodwaters had reached a depth of about eight feet.

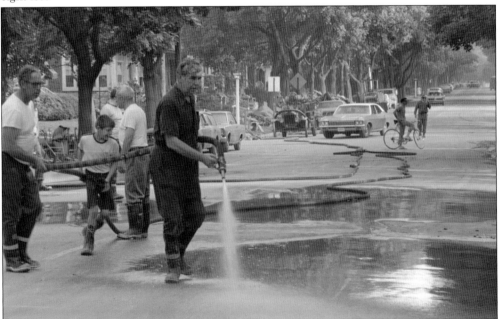

Near the intersection of North Second and Vaughn Streets, community members gather to clean the mud from the streets. The 1918 Model TT Howe Fire Truck in the center background was brought to Harrisburg in 1951 and used by the Riverside No. 15 Volunteer Company as a showpiece in parades. It later disappeared, only to be found in 2002 by Linn Lightner, who has since restored the truck to its original condition.

The doors to the Kesher Israel Synagogue at 2500 North Third Street are left propped open to air out the water-soaked building as the damaged carpets and fixtures are removed and piled up outside.

Several hundred Anabaptist Amish and Mennonite volunteers arrived in the Harrisburg area to lend a helping hand cleaning the homes and businesses of the flood victims. Here, a group of Mennonite women from Lebanon County go door-to-door on the 2700 block of North Second Street with their cleaning buckets in hand.

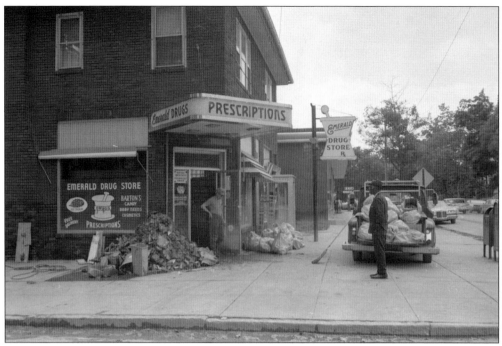

Although the water had receded, the high-water mark was still visible along the side of the Emerald Drug Store at the corner of North Third and Emerald Streets. The trash and water-damaged goods next to the door were piled up nearly as high as the mark.

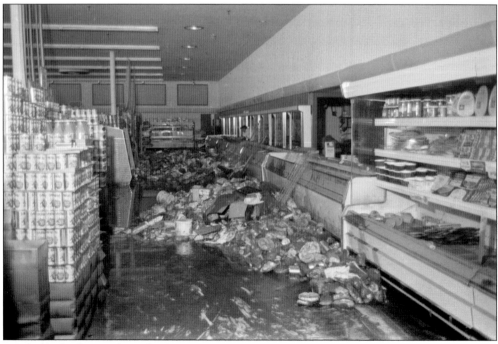

Perishable food items from the freezer and refrigerated cases are tossed onto the floor to mingle with the layer of mud left behind at the Weis supermarket on North Third Street next to the Emerald Drug Store.

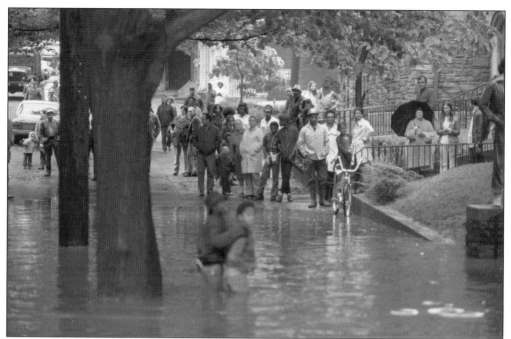

Above, a crowd congregates on the dry land outside of the Church of Our Lady of the Blessed Sacrament at the corner of North Third and Woodbine Streets. Two blocks to the south, smoke and flames reach into the sky as a section of row homes on North Second Street burn out of control.

On the morning of June 23, sightseers on both shores of the Susquehanna River who came out to witness the flooding could also see smoke billowing above the treetops in midtown Harrisburg. Believed to have been the result of a gas leak, fire erupted in the 2100 block of North Second Street, near the Governor's Mansion. At the time of the fire, the river was still rising, and the homes on Second Street were surrounded by more than six feet of water.

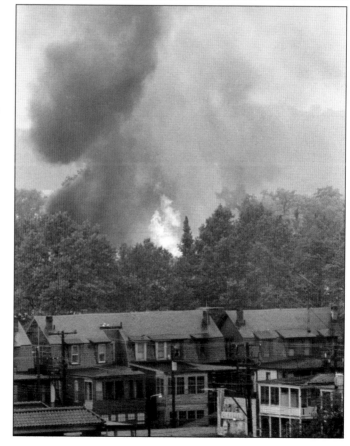

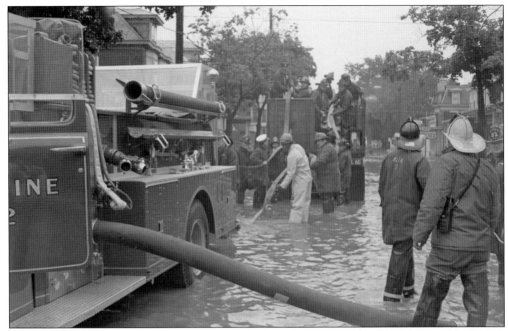

Responding to the fire call, these fire trucks were brought onto Maclay Street but could advance no further than Susquehanna Street due to the deepening floodwaters, which caused the trucks to stall. The firefighters were still three blocks away from the blaze, and assistance was required from the National Guard, who provided a transport truck for the operation.

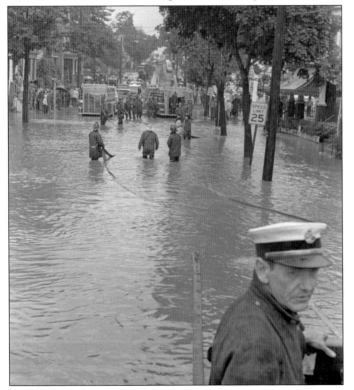

As the city fire trucks were unable to venture into the floodwaters, hoses were loaded onto a National Guard transport truck. The transport truck was able to advance the fire crews and their equipment closer to the blaze but only as far as Green Street, still two blocks away from the fire.

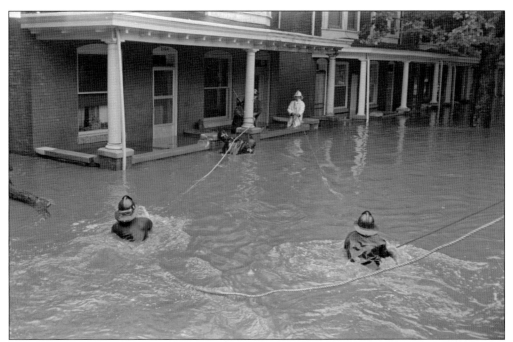

From their position on Green Street, the firefighters swam out into the floodwaters with rope lines, which were secured to houses and used as lifelines in the deep water. Above, Chief Charles A. "Chet" Henry, dressed in light-colored gear, secures the rope lines to the front-porch support posts of the homes at 2134 and 2136 Green Street.

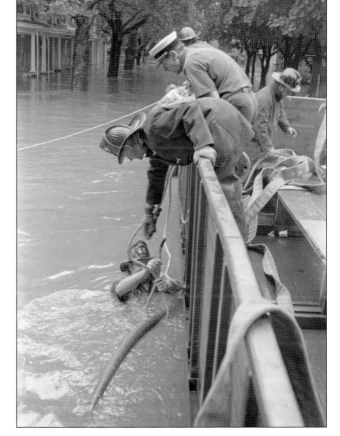

Once the lifelines were secured, the hose was then tied off to a rope line that could be pulled through the water. From this location, the firefighters still had to navigate in between the houses and backyards between Green and Penn Streets, towing the hose along with them.

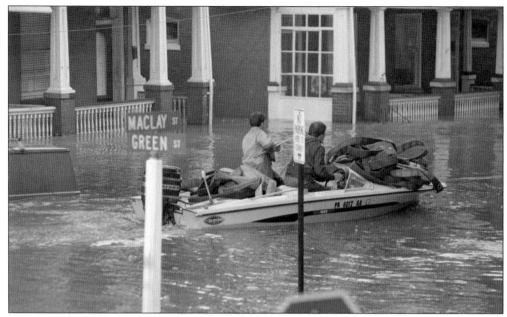

Facing unusual circumstances, unconventional means were needed to reach the fire surrounded by floodwaters on North Second Street. Here, a boat carries several lengths of fire hose towards the fire. The firefighters were ultimately able to reach the blaze, with a few of them able to fight the fire from the rooftops of the homes on Penn Street.

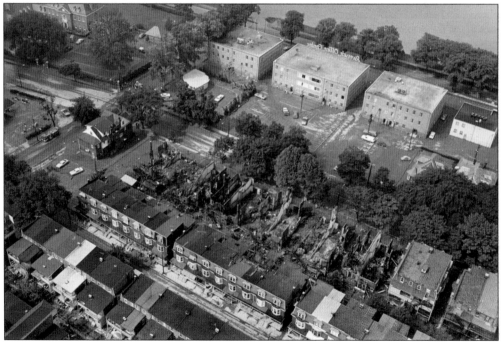

Unfortunately, the blaze had become too large to gain control over, and it eventually burned out when it reached the water level. Ultimately, 12 homes from 2115 to 2137 North Front Street were destroyed in the fire. Behind these residences, the homes at 2134 and 2136 North Penn Street were also damaged and eventually torn down.

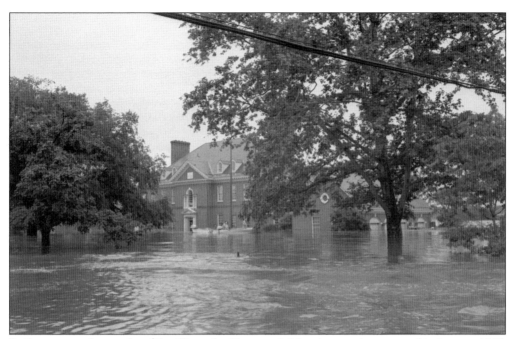

Built at a cost of more than $2 million, the Governor's Mansion was inaugurated in January 1969. Surprisingly, while this new executive residence saw as much as five feet of water on the first floor, the governor's residence it replaced at 313 North Front Street remained above the waterline.

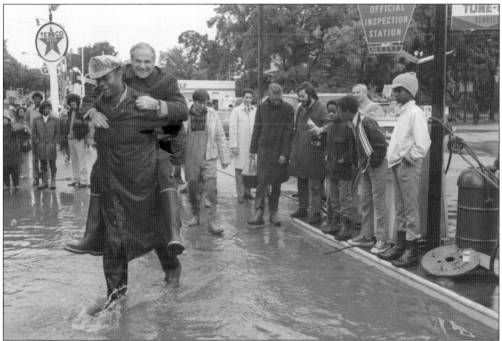

At first glance, this photograph of Gov. Milton Shapp being carried across the flooded parking of the Texaco Station near Third and Maclay Streets seems a bit unflattering. However, he was not being carried out of the floodwaters, but instead to a boat that was headed back to the executive mansion.

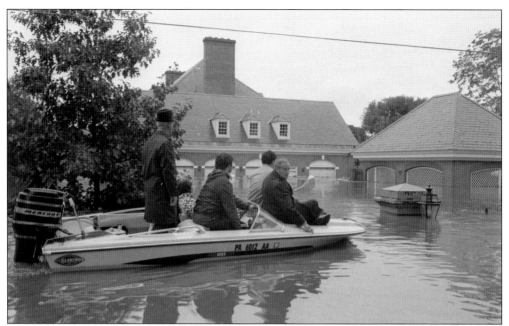

On Friday, June 23, presumably after the fire crews had left the scene of the North Second Street fire, Gov. Milton Shapp, along with his wife, Muriel, and his staff, boarded the same boat that was used to carry hose to the fire earlier in the day and navigated their way over the iron fence onto the "grounds" of the executive mansion to gather items and appraise the extent of the flood damage.

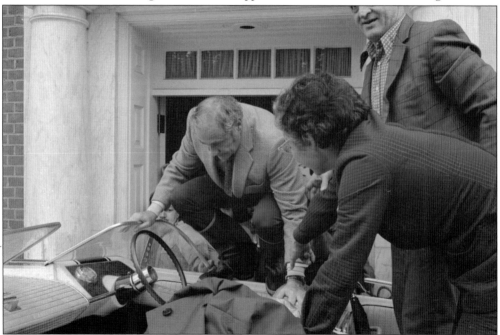

While this photograph appears to show the first couple of Pennsylvania evacuating from the executive mansion, they were actually returning to it during the height of the flood to appraise the damage. Although not seen here, one item that was rescued from the mansion was a large black chow, presumably the first dog of the state.

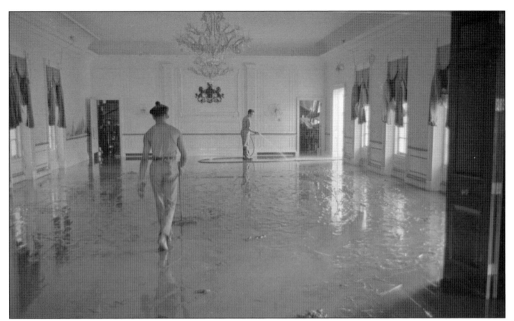

Above, a cleanup crew removes mud from the state dining room of the Governor's Mansion. Many of the mansion's valuable furnishings were moved to the second floor late on Thursday, June 22, when the river stage was approaching 26 feet. The mansion began to flood when the river reached between 28 and 29 feet. By 3:00 a.m. the next morning, the river stage had reached 28 feet. After the flood, one spokesperson for the governor's office commented to the *Patriot-News* on the location of the new executive mansion, stating, "We have learned from disaster and experience that the mansion is in the wrong location, situated as it is in a commercial area and subject to another disaster. It may now be necessary to find an entirely different site."

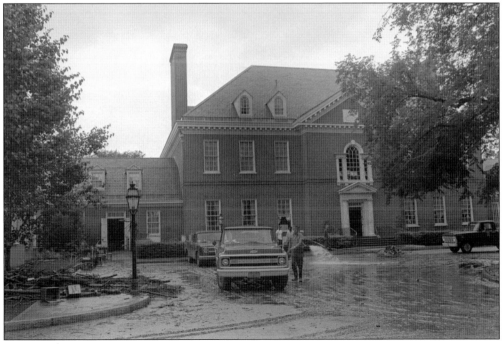

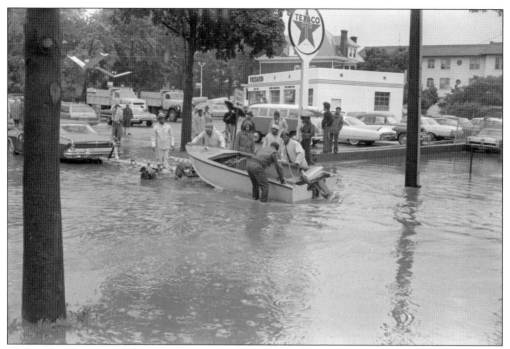

On Maclay Street just below the Texaco station at the corner of Third Street, a boat is unloaded from its trailer. It was here, earlier in the day on June 23, that the city fire trucks were halted by the floodwaters in their efforts to respond to the blaze on North Second Street.

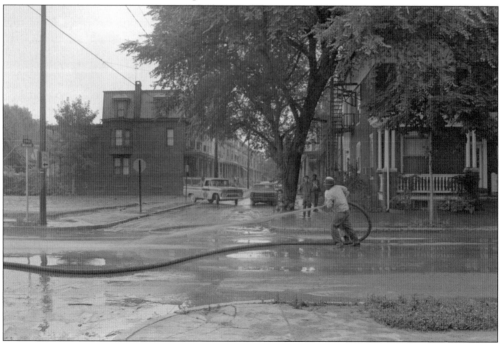

With the aid of a fire hose, two men attempt to push the mud from the intersection of Maclay and Penn Streets back down towards the river. At the left edge of the photograph, to the left of the street signs, is a portion of the burned-out remains of the homes on North Second Street.

Two young women give a wide berth to the cleanup operations taking place at the Geigle Funeral Home at the corner of North Third and Maclay Streets.

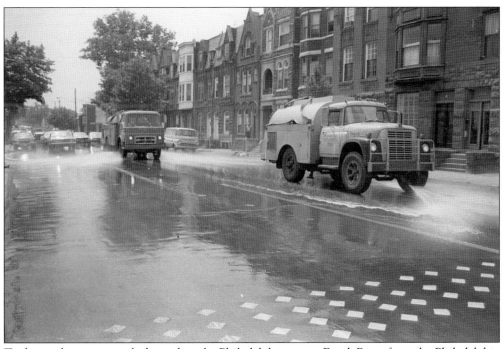

Tanker and sweeper trucks loaned out by Philadelphia mayor Frank Rizzo from the Philadelphia Department of Streets helped clean the city streets of any mud that still remained after the flood. Here, they make a pass up North Second Street near Reilly Street.

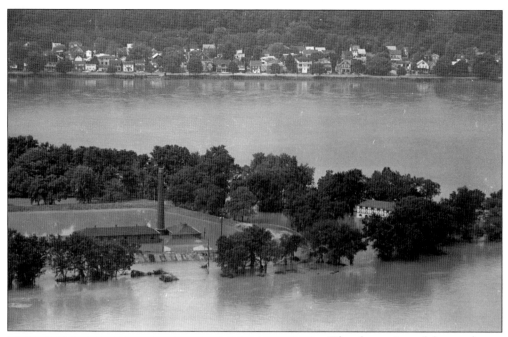

The above view of the north end of City Island was taken as the floodwaters were receding. The water-filtration plant and reservoirs seen here were constructed in 1904 and used to extract and filter water taken from the river, which was then pumped over to the Front Street Pumping Station for eventual use in the city. The damage sustained from Agnes made it prohibitive for the facility to be brought back into working order.

The high-water mark is painted on the support post at Front Street Pumping Station, also known as the Old Waterworks. The lines document the floods in the city dating back to 1846. Built in 1841, the facility originally pumped water directly from the Susquehanna River to the city's reservoir. After being damaged by Agnes, the facility ceased operation as a pumping station.

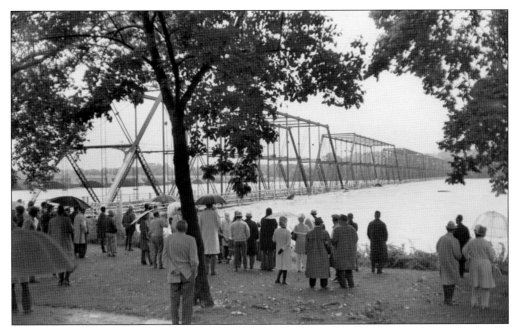

A crowd gathers along Riverfront Park to watch the Susquehanna River rise up to meet the Walnut Street Bridge. Also known as the People's Bridge, it was under construction during the flood of 1889, which brought the river up to a crest of 26.8 feet in Harrisburg and placed the deck of the eastern side of the bridge under several feet of water. This prompted the builders to raise the bridge deck an additional six and a half feet.

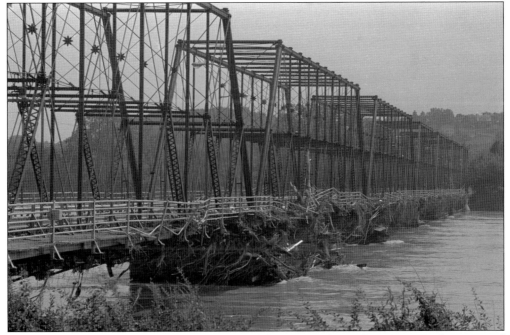

After withstanding everything that Agnes could throw at it, the Walnut Street Bridge managed to remain intact, suffering just some minor cosmetic damage. However, following the flood, the bridge was closed to automobile traffic and only served pedestrians going forward.

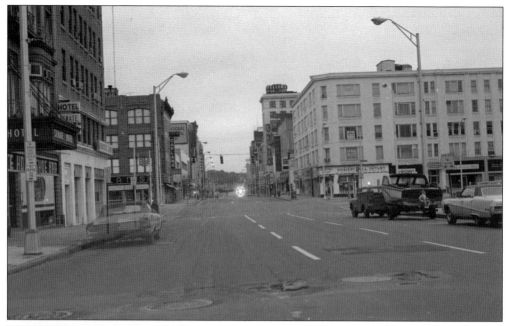

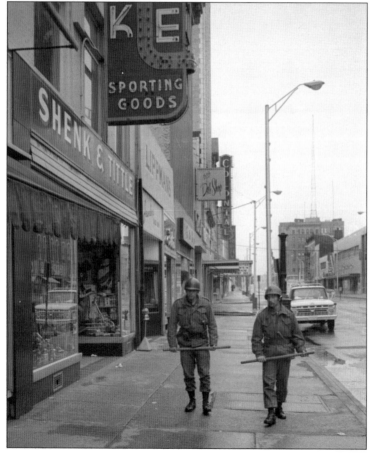

Above, during the hours of the imposed curfew and limited accessibility to the downtown area, Market Square looked like a ghost town. Even the car parked on the left side of the street took on a similarly ghostly appearance.

Two National Guardsmen, batons in hand, patrol Market Street in an effort to quash any ideas of looting abandoned downtown businesses. By Monday, June 26, a total of 800 National Guardsmen were serving on active patrol duty in the city.

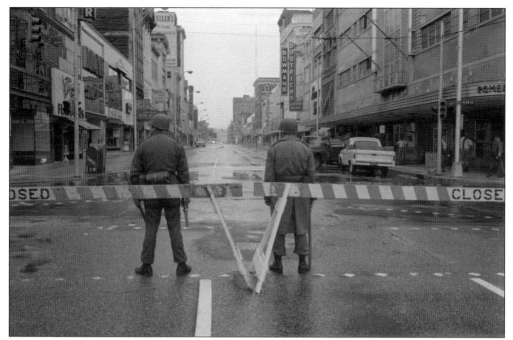

Two National Guardsmen stand at their post at Fourth and Market Streets. While Market Street from Front Street to Fourth Street stayed relatively dry, several of the businesses there did receive a significant amount of water in their basement levels. It was reported that the merchandise in Pomeroy's Department Store was floating in six feet of water.

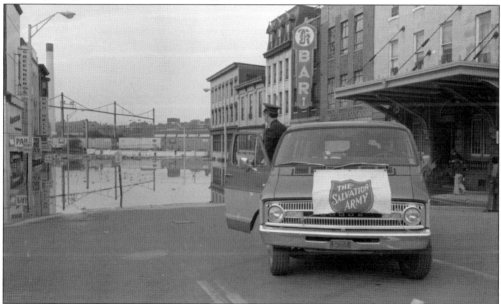

While Market Street remained dry at Fourth Street, from there down to the subway was a different story. Two factors contributed to the flooding of the subway on Market Street. The runoff from 12 inches of rain draining down to the lower elevation began the process, but ultimately, the sheer volume of water from Paxton Creek filled the subway and backed the water up the hill to the steps of the Plaza Hotel near Grace Street.

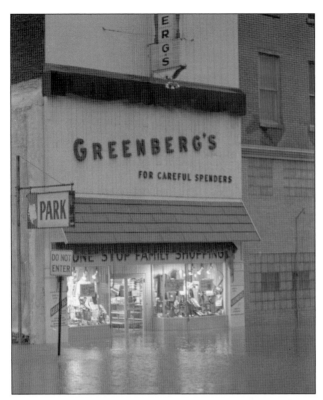

Greenburg's Department Store was located at 430 Market Street in Harrisburg, the current location of the parking garage for the Rachel Carson Building. The lights remained on in the store when this photograph was taken. It is not certain if they were holding out for last-minute customers or just trying to deter looters.

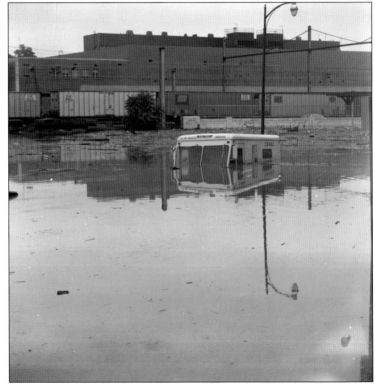

A mail truck sits nearly submerged on Fifth Street just above Market Street and the subway. The water has risen so high that the entrance to the subway is completely obscured.

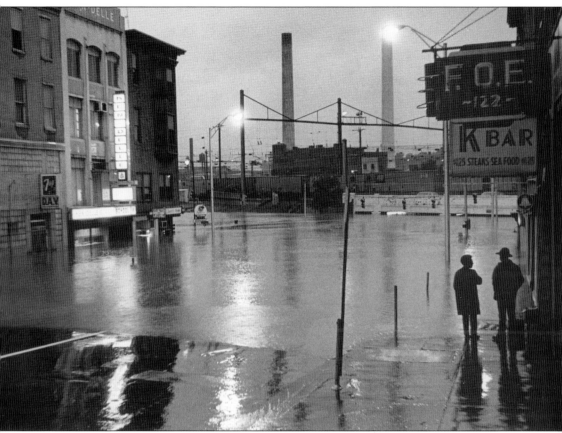

This nighttime scene of Market Street between Grace Street and the subway shows that, as with Greenburg's Department Store, the lights remained on in many businesses during the flood. Even the fluorescent lights in the subway continued to glow as the floodwaters rose to meet them.

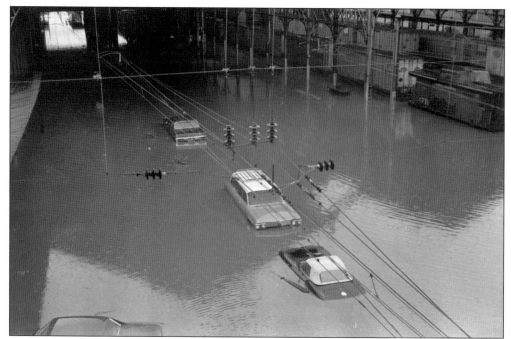

While the train cars on the subway overpass stayed barely above the flood line, these automobiles and train cars just a short distance away in the Penn Central train yard were not so lucky. Here, the floodwaters, primarily from Paxton Creek, were still several feet deep.

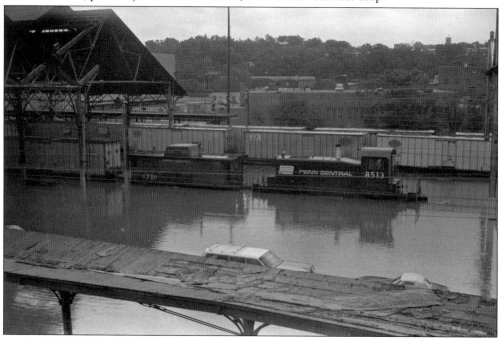

As a result of the flooding in the Harrisburg train yards, a significant amount of people and freight were left stranded throughout the region, unable to move through the important hub of Harrisburg. This Penn Central SW-1 locomotive sits idle behind the freight cars, unable to perform its normal duties.

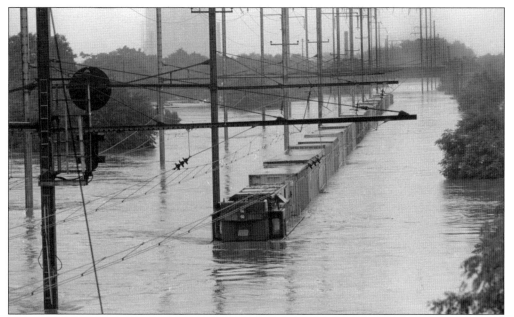

In this view looking south from the Mulberry Street Bridge, the Penn Central 4422 E44 electric locomotive, along with its complement of boxcars, was stranded in the floodwaters.

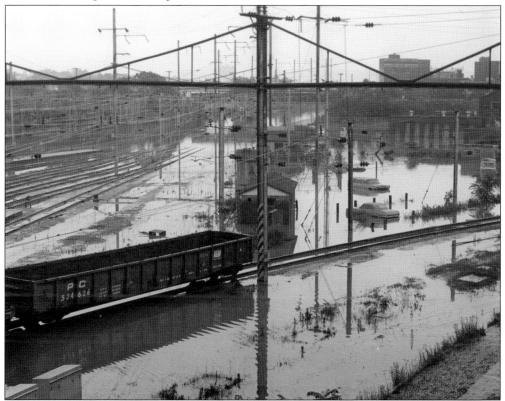

As the floodwaters subsided, the rail yard below the station was relatively barren except for one Penn Central open gondola car and a few forgotten automobiles.

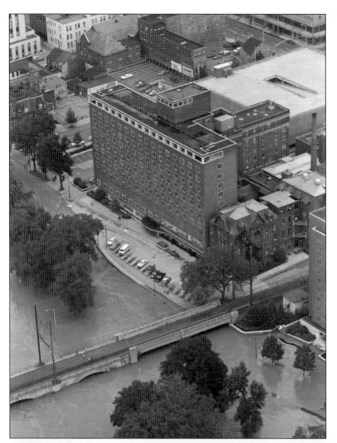

This aerial view of Front Street, taken on June 24, shows that even at their crest, the floodwaters were not high enough to reach Harrisburg Hospital's main building. Brady Hall, however, was a different story. Of note here is the hospital's old building, which was still part of the hospital complex.

The photograph below of South Front Street near Washington Street was taken on the evening of June 22, when the Susquehanna River had risen to a level near 26 feet. The water here is deep enough to keep a boat buoyant but not quite deep enough to close up the Nationwide Inn, where the lights are still on in the lobby.

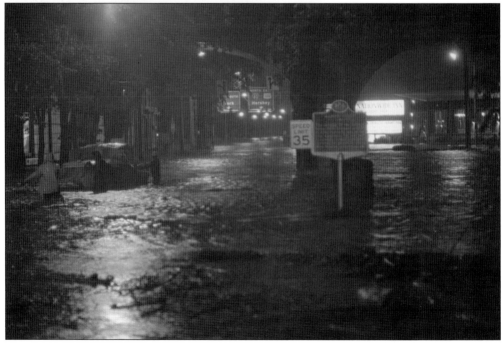

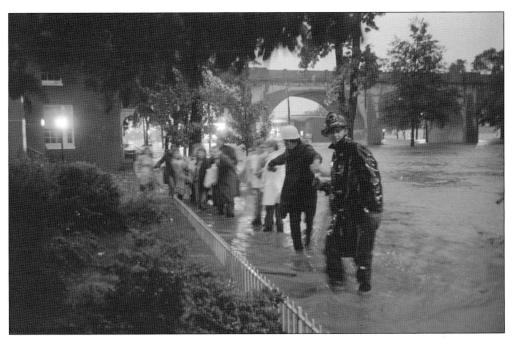

Acting out a strange version of follow-the-leader, emergency personnel and residents evacuate during the night from the Medical Arts Building and travel up South Front Street through the rushing floodwaters to reach higher ground.

The floodwaters from the Susquehanna River have disappeared from South Front Street near the Harris-Cameron Mansion, but the mud remains. However, the coating of mud does not extend up to the rise at Mary Street, where John Harris elected to build his riverfront home, following the beliefs of local Native Americans that this particular site did not flood. This theory held true during Agnes.

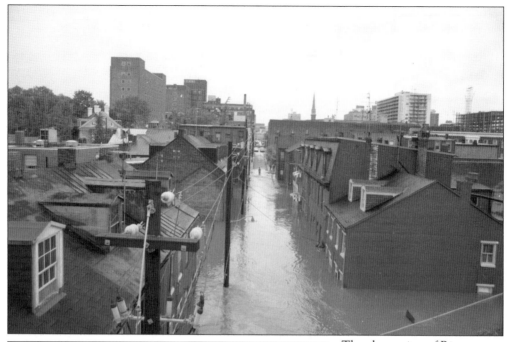

The above view of River Street was taken from the elevated vantage point of the Philadelphia & Reading Railroad Bridge with Washington Street in the distance. On the right, the two closest row homes, with the extended dormers, were lost in the flood when their foundations became unstable.

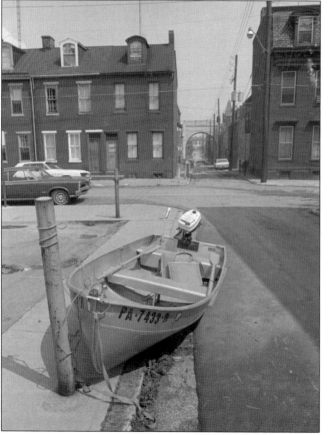

Strangely out of place, a seemingly forgotten boat is left tied to a post on River Street, directly behind the carriage house on the grounds of the Harris-Cameron Mansion. The post where the boat is tied was actually on dry land, as the intersection of River and Washington Streets only saw between one and two feet of water.

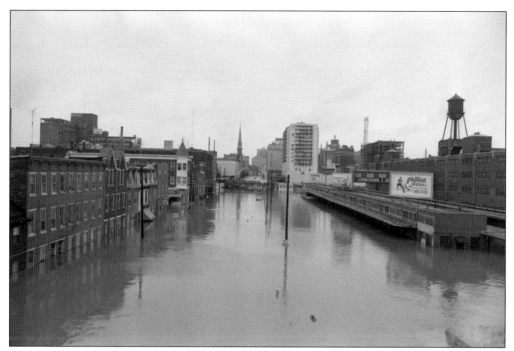

This view looking north on Second Street towards Market Square shows that the floodwaters extended north up to the underpass of the Cumberland Valley Railroad Bridge. To the left, at the intersection with Washington Street, is Santanna's Restaurant. The large building complex on the right is the Pennsylvania Railroad Freight Station.

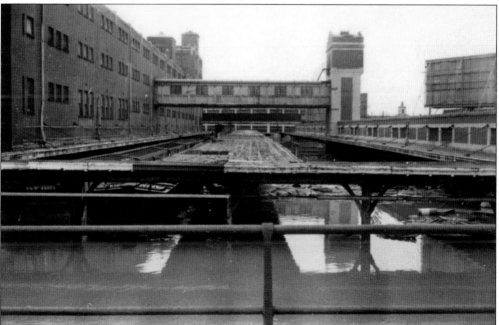

This view provides a closer view of the Pennsylvania Railroad Freight Station complex, as seen from the Cumberland Valley Railroad Bridge looking south. The tops of the boxcars left at the loading docks are just above the waterline.

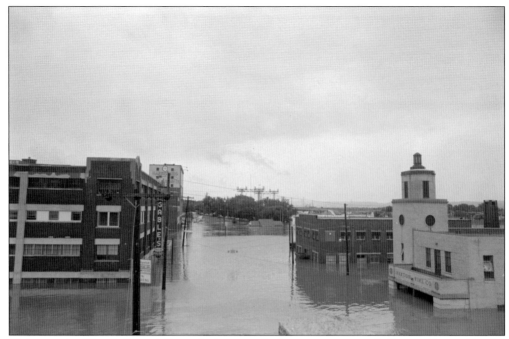

This view is of South Second Street looks towards the intersection with Paxton Street. On the right is the Paxton Fire Company, with the Bell Telephone Company building just beyond it. On the left is Gable's Appliance and Hardware dealership, with the Harrisburg Moving and Storage Company behind it.

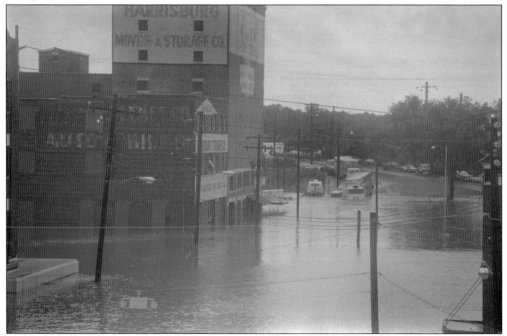

A closer look at South Second Street at the intersection with Paxton Street reveals one of the few locations that remained above the floodwaters. The Paxton Street Bridge, which crosses over the railroad tracks, became a prime parking location during the flood.

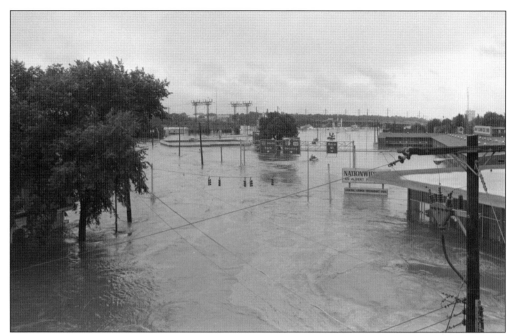

This intersection, the convergence of South Front, Paxton, Race, and Vine Streets, also served as the convergence of Paxton Creek from the left and the Susquehanna River from the right, with Shipoke in the middle. In the distance to the right, the first floor of rooms at the Nationwide Inn is nearly covered by the floodwaters.

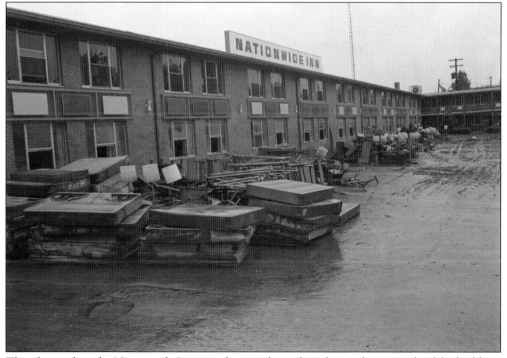

The aftermath at the Nationwide Inn, seen here in the parking lot on the river side of the building, left very little to be salvaged.

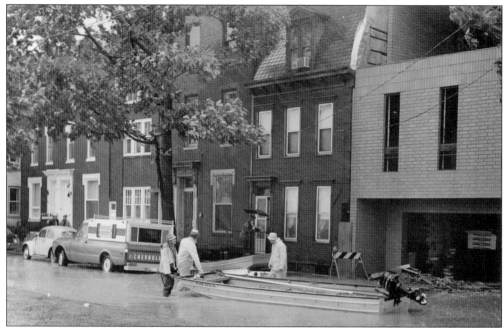

These two photographs show South Front Street in Shipoke. Above are the homes on the 500 block, near the intersection with Tuscarora Street. Below is the 600 block, continuing down from Tuscarora. The first four homes, at 601, 603, 605, and 609 South Front Street, were all lost due to the flood. Only the home to the far right of this view, at 615 South Front Street, remains to this day. Both of these views were taken on June 22, and while the Susquehanna River had still not risen over its banks at this location, South Front Street was already flooding due to the incredible amount of rain and the runoff from Paxton Creek.

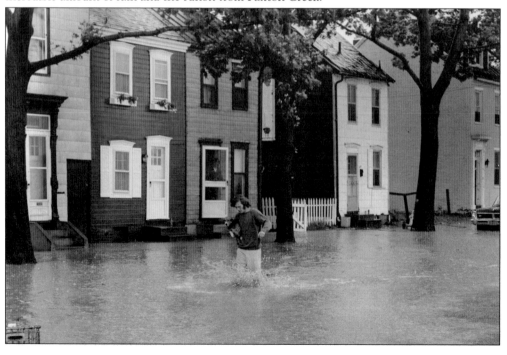

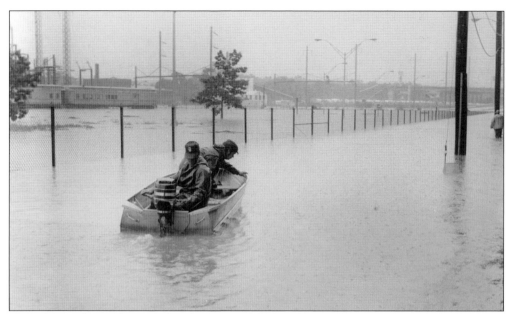

According to the residents of Shipoke, the neighborhood begins to flood from overflowing drains when the Susquehanna River reaches a level of about 19 feet. However, the river will not spill over its banks until it reaches a level of about 24 feet. The official rainfall amount for June 21 was 5.81 inches. The river stage at 1:00 a.m. on June 22 was 6.3 feet and rising. By 1:00 p.m. on June 22, only 12 hours later, the river had risen to 15.63 feet, Paxton Creek had come crashing through the city, and the better part of nine inches of rain had fallen that morning. These two views of Shipoke were taken on June 22. Above, a boat travels down Race Street; below, in the background, an abandoned Volkswagen Beetle slowly disappears beneath the rising waters on Nagle Street.

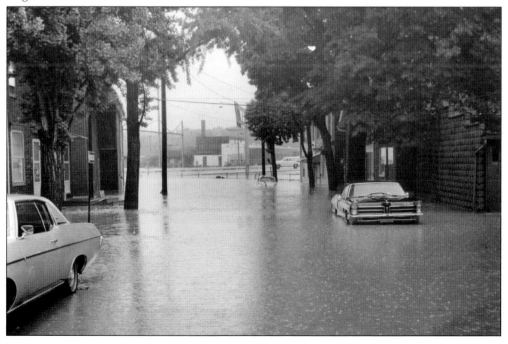

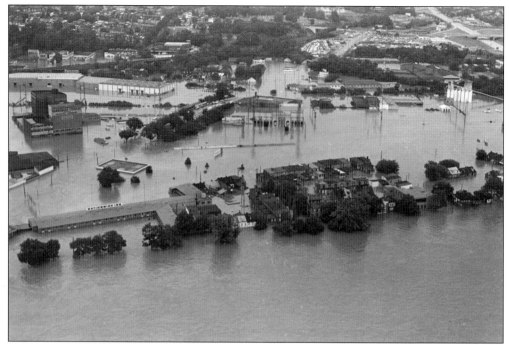

This aerial view, taken on June 24, shows the extent to which the Susquehanna River will flood the southern end of Harrisburg when the river stage reaches 32 feet, reaching all the way from South Front Street, where the homes in Shipoke are flooded up to their second stories, to Cameron Street, which saw between six and eight feet of water in some places.

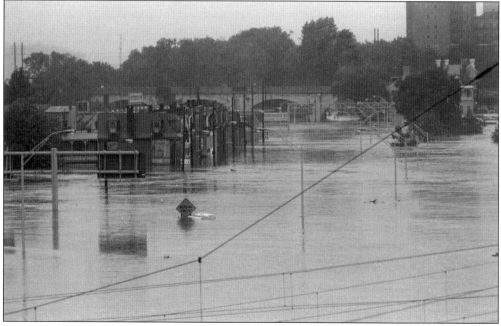

This view of Shipoke was taken on June 24 from the elevated vantage point of Route 83 as the floodwaters from the Susquehanna River were cresting. The water levels had risen nearly to the second stories of the homes along Race Street.

It is hard to tell who got the worst of it here, the larger Chevy Bel Air or the smaller Opel Kadett wedged underneath it. Oddly enough, while the Nationwide Inn parking lot is covered with a layer of mud several inches deep, both cars remained relatively clean, at least on the outside.

Personal belongings and furniture, waterlogged and covered with mud and filth, are piled high along the street by a resident of the apartments at 331 South Front Street.

Discover Thousands of Local History Books
Featuring Millions of Vintage Images

Arcadia Publishing, the leading local history publisher in the United States, is committed to making history accessible and meaningful through publishing books that celebrate and preserve the heritage of America's people and places.

Find more books like this at
www.arcadiapublishing.com

Search for your hometown history, your old stomping grounds, and even your favorite sports team.

Consistent with our mission to preserve history on a local level, this book was printed in South Carolina on American-made paper and manufactured entirely in the United States. Products carrying the accredited Forest Stewardship Council (FSC) label are printed on 100 percent FSC-certified paper.

MADE IN THE

USA